B

PLANTS & GARDENS

BROOKLYN BOTANIC GARDEN RECORD

GARDEN PHOTOGRAPHY

1990

Brooklyn Botanic Garden

STAFF FOR THE ORIGINAL EDITION:

CHARLES MARDEN FITCH, GUEST EDITOR

BARBARA B. PESCH, EDITOR

STAFF FOR THE REVISED EDITION:

BARBARA B. PESCH, DIRECTOR OF PUBLICATIONS

JANET MARINELLI, ASSOCIATE EDITOR

AND THE EDITORIAL COMMITTEE OF THE BROOKLYN BOTANIC GARDEN

BEKKA LINDSTROM, ART DIRECTOR

JUDITH D. ZUK, PRESIDENT, BROOKLYN BOTANIC GARDEN

ELIZABETH SCHOLTZ, DIRECTOR EMERITUS, BROOKLYN BOTANIC GARDEN

STEPHEN K-M. TIM, VICE PRESIDENT, SCIENCE & PUBLICATIONS

COVER PHOTOGRAPH BY ELVIN MCDONALD

PHOTOGRAPHS BY CHARLES MARDEN FITCH, EXCEPT WHERE NOTED

PRINTED AT SCIENCE PRESS, EPHRATA, PENNSYLVANIA

Plants & Gardens, Brooklyn Botanic Garden Record (ISSN 0362-5850) is published quarterly at 1000 Washington Ave., Brooklyn, N.Y. 11225, by the **Brooklyn Botanic Garden, Inc.** Second-class-postage paid at Brooklyn, N.Y., and at additional mailing offices. Subscription included in Botanic Garden membership dues ($25.00) per year). Copyright © 1989, 1990 by the Brooklyn Botanic Garden, Inc.

ISBN # 0-945352-53-0

PLANTS & GARDENS

BROOKLYN BOTANIC GARDEN RECORD

GARDEN PHOTOGRAPHY

THIS HANDBOOK IS A REVISED EDITION OF PLANTS & GARDENS, VOL. 45, NO. 2

HANDBOOK # 120

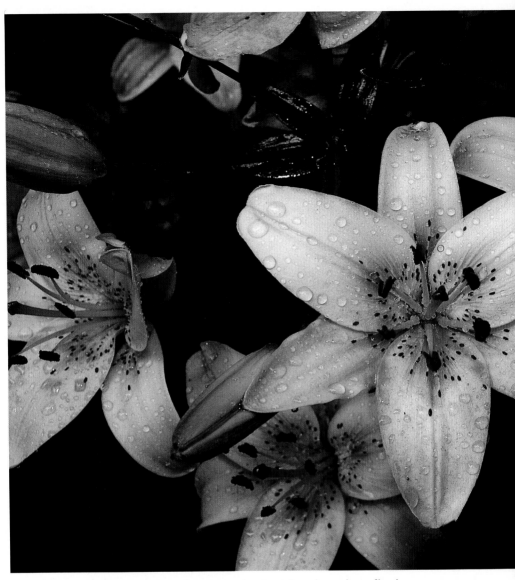

Lily 'Sirocco' photographed with a hot shoe flash
shows dark background since the exposure was correct only for the
distance between flash and flowers.

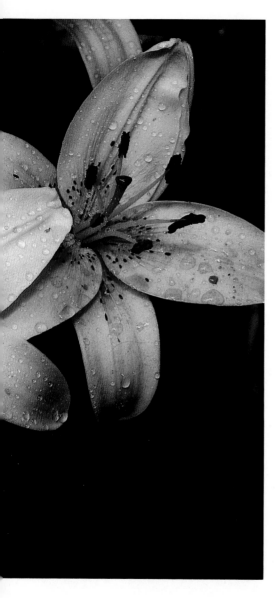

FOREWORD

Each gardener knows his or her own garden and the plants therein better than anyone else. Not only do gardeners know their plants and gardens, but they know the effects of light shifts at different times of the day, as each season changes—after a rain, a heavy dew, a new snowfall.

These intimate facts equip such gardeners to capture their own creations on film. This record can be used to document successes and failures for the future. Those plants that successfully worked in the scheme of things can be repeated—those that did not can be avoided.

This visual history along with a gardener's notes can be invaluable as a reference. Not only will the record be useful, but capturing plants at their best is an art in itself and the results will be as rewarding to some as the act of gardening itself.

Gertrude Jekyll, especially in her later years when her eyesight was failing, used photography to create a visual record and to communicate her ideas of garden design to others. Her visual and verbal record survives to guide us as your record can guide and inspire you.

We wish you good gardening and good photographing.

BARBARA B. PESCH
EDITOR

NOTES FROM THE GUEST EDITOR

The articles in this handbook reflect the individuality of each contributing photographer/author. Each has his favorite cameras, films and approaches to plant photography. But a sensitivity to nature and a desire to capture beauty on film is the common characteristic of these garden photographers.

Photographic equipment varies around the world. The most suitable tripod for my work may not match your needs. Your favorite film might not suit someone else's goals. Some specific brand names are mentioned in this handbook for your convenience. However, mention of a film brand or camera model does not imply that other brands may not be equally suitable.

An excellent way to study appropriate equipment and film is to visit a professional photographic store. Ask questions and be specific about your photographic goals. Local camera clubs are another helpful source because members enjoy talking about their favorite approaches to photography.

Many botanical gardens and universities offer short courses on photography. Some offer specific classes in plant photography. Courses offer an excellent opportunity to learn from experienced photographers.

Finally, supplement this handbook with additional reading in the area of your special interest. Check the library and bookstore for photography titles in close-up work, landscape photography, studio techniques, travel and nature photography.

Study the instruction booklets for each piece of equipment you use. Keep the instructions for future reference. Capturing landscapes, habitats, and plant portraits on film is an exciting blend of science with art. Being a gardener is the best start toward becoming an excellent horticultural photographer.

CHARLES MARDEN FITCH
GUEST EDITOR

Photographer/horticulturist CHARLES MARDEN FITCH *travels the world documenting plants in their native habitats. His assignments include documentary science projects in Latin America with the U.S. Department of State, the Organization of American States and the Peace Corps. Fitch is author of numerous books including the* **Rodale Book of Garden Photography** *and* **All About Orchids**. *More than 2,000 of his plant portraits taken in Africa, Asia, South Pacific and Latin America appear in 'Exotic Plants,' a video laser disc compendium. Charles Marden Fitch was guest editor for P&G handbooks:* **Indoor Gardening** *and* **Orchids**.

Photographer Fitch capturing begonias in their tropical Costa Rican habitat.

6

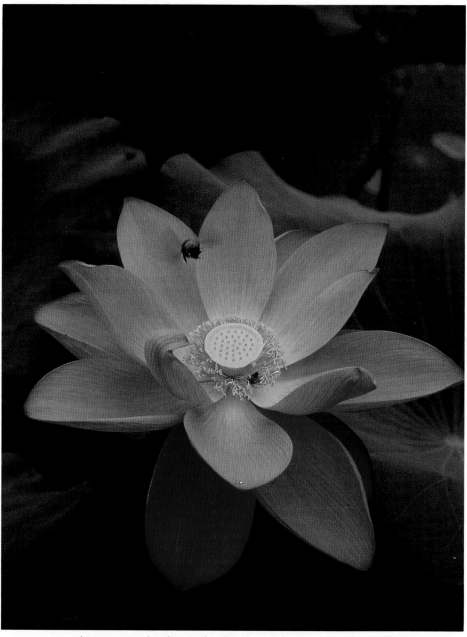

By choosing a high angle this lotus flower in Wuxi China
was placed against its beautiful floating foliage.
The hovering bee at left center is slightly blurry because the shutter was
not fast enough to stop the rapidly moving wings.

Choosing the correct angle when photographing home gardens and landscapes is important. This courtyard garden in China shows specimen trees in relationship to the ornate facade of the house.

GARDEN PHOTOGRAPHY:
TAKING TIME TO
COMPOSE FINE PHOTOS

ROBERT S. HARRIS

G ardeners know there are only a few precious days when most flowers are in perfect bloom at peak color. And, when tomatoes are luscious red and ripe for picking, you're tempted to freeze that moment to capture your proudest produce.

ROBERT HARRIS, *teacher, lecturer and world traveler is a photographer for Eastman Kodak Company's multimedia travel productions. He holds a Master of Photography degree and has won many awards for his photographs. Bob assisted in photographic training of NASA astronauts and has contributed articles to magazines such as* **Popular Photography** *and* **Petersen's Photographic**. *His photo features also appear in several Kodak books.*

Whether your goal is to display prize-winning flowers or glistening fruits and vegetables from your garden, time often is the deciding factor. Garden displays, whether public or private, only last as long as weather permits, but the tools to capture their peak brilliance are within reach, in the form of a camera loaded with film.

Garden photography is rewarding, and the enterprising picture-taker can make the most of a colorful flower bed, a crisp, bright day, and today's easy-to-use films and cameras. A major advantage for garden picture-takers is the familiar land-

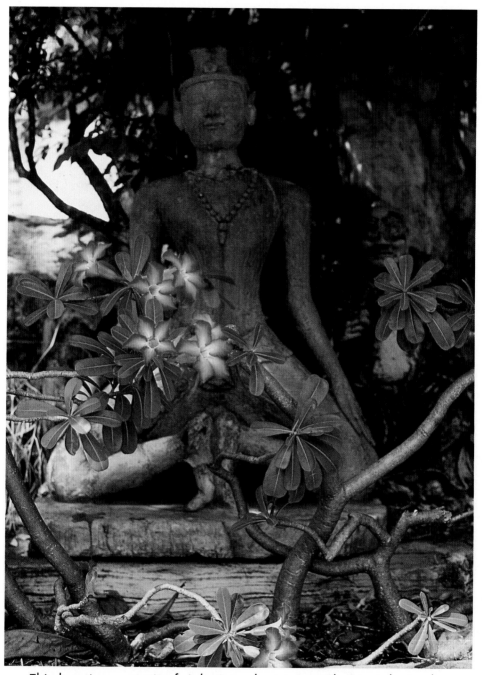

This location portrait of *Adenium obesum* in a Thai temple garden
includes an outdoor image of Buddha.

scape. No one knows your rose bushes as well as you do, and a familiarity with your subjects—whether plants or people—often adds a relaxed, comfortable aspect to your picture-taking. What's more, the veteran gardener often can apply his or her expertise when photographing a public garden.

Unlike action photographs, garden photography gives you fewer variables. Except for an occasional breeze, plants rarely move, so stopping action or hurried refocusing are seldom problems. Time is on your side; lilacs do not attack curious camera carriers.

Whether a garden is large or small, most picture-takers can orchestrate their scenes to capture exceptional floral images on film. When you take a camera in hand, you choose the time of day when lighting conditions are most suited to your photographic needs. A quick check of the local weather report can help you plan a productive day behind the camera.

One of the best ways to get good garden photos is to become familiar with the tools at hand, in this case, your camera and film. Just as pianists rely on fine instruments as well as their natural skills, you need to develop a rapport with your picture-taking tools. Once you feel confident using a camera, your sense of creativity can emerge.

Selecting Cameras and Films

For any picture-taking endeavor, a basic guideline is to "keep it simple." This is especially applicable for garden photographers, whether you use a sophisticated single lens reflex (SLR) camera or a compact, automatic camera. Vibrant colors and interesting shapes abound in your garden, so it's often easy to capture the images you want. Such photos, however,

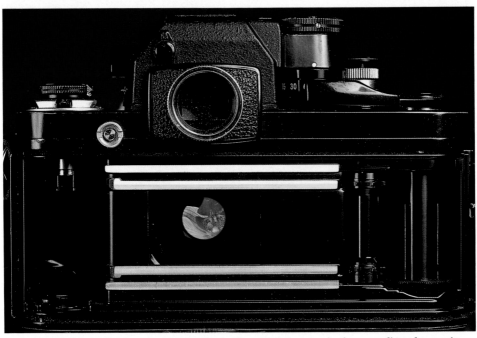

Looking through the open shutter of a 35mm single lens reflex from the film's point of view.

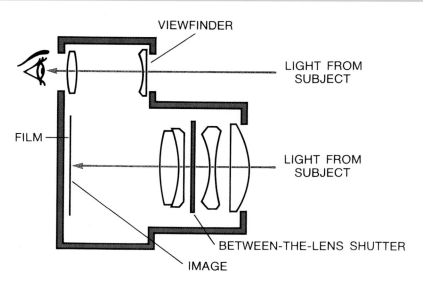

VIEWFINDER

LIGHT FROM SUBJECT

FILM

LIGHT FROM SUBJECT

BETWEEN-THE-LENS SHUTTER

IMAGE

CAMERA WITH DIRECT OPTICAL VIEWFINDER
This type of viewfinder is used in rangefinder cameras.

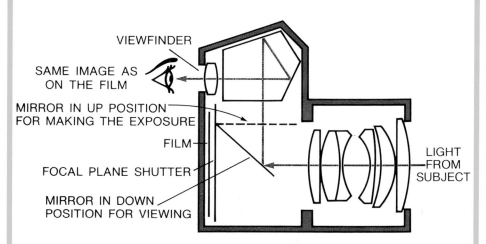

VIEWFINDER

SAME IMAGE AS ON THE FILM

MIRROR IN UP POSITION FOR MAKING THE EXPOSURE

FILM

FOCAL PLANE SHUTTER

MIRROR IN DOWN POSITION FOR VIEWING

LIGHT FROM SUBJECT

CAMERA WITH SINGLE-LENS-REFLEX VIEWFINDER
A movable mirror directs the image formed by the camera lens up through a pentaprism in the viewfinder to your eye. When you take the picture, the mirror moves up out of the image path so the image strikes the film. After the exposure is made, the mirror moves back into position in front of the film for viewing.

DRAWINGS COURTESY OF EASTMAN KODAK CO.
FROM "BETTER 35MM PICTURES"

Tight composition places a potted *Podocarpus* just off center so the view can include some of the appropriate background, here Ching Chung Koon temple in Hong Kong.

require attention to composition, lighting and background. The right camera can make these details easier to control.

Many picture-takers today prefer cameras that use 35mm film for either slides or prints. Whether you prefer the detailed control of SLR cameras—with interchangeable lenses and variable shutter speeds—or the decision-free features of automatic cameras, look for an easy-to-use, reliable model that feels comfortable in your hands.

In compact cameras, many of the exposure, film speed and even focusing procedures are automatic. For example, the Kodak S100EF camera is designed for ease-of-use, with a fixed-focus, three-element glass lens, automatic exposure, and a built-in electronic flash. For greater options, the Kodak S900 Tele camera offers two built-in lenses—a 34mm wide-angle lens for full views and a 62mm telephoto lens for close-ups. The lenses change at the touch of a button; when used in telephoto mode, the camera automatically focuses on the subject of the photo.

Black-and-white films are preferred in photojournalism, but the beauty of plants and flowers is best captured on color film. How you plan to display your photographs helps determine whether you use color print or color slide films. For color photographs to place in frames or albums, a color negative film is preferred. If you plan to produce photos for publication or projection, color slide film is best.

Film speed is an important element of photography, but an easy aspect to understand. All films have ISO numbers; the higher the number, the greater a film's sensitivity to light. A film with an ISO number of 100, for example, works well in bright daylight scenes, while an ISO 400 film is preferred when less light is available.

Because of the garden photographer's attention to detail—the delicate patterns of a rose, for example—slow- or moderate-speed films often work well for color prints. Kodacolor Gold 100 or Kodacolor Gold 200 films offer fine grain for detailed images, as well as rich colors important to hobbyists and professional photographers. You will also find these films produce images which can be easily enlarged. In addition to a snapshot of your most glorious gladiolus, you can use the same 35mm negative to order a handsome 8 x 10-inch print, suitable for framing.

Once you've selected a camera and film, try them out on everyday scenes to become familiar with the operation of the camera. Experiment first with simple snapshots of family or friends to get accustomed to the feel of the camera. If

you're used to older, metal-bodied cameras today's lightweight models may surprise you. After taking a few photos, you'll also have a better idea about how to plan the images you want to take.

Every photographer's goal is to capture both the drama and the subtleties of colors in a balanced, attractive picture, presenting the images in a harmonious composition. That's not nearly as difficult as it might sound.

Creating a Scene with Light and Color

Composition, lighting and background are often the factors that make the difference between good photographs and exceptional ones. By becoming familiar with each of these concepts and putting them to work for you, you can capture garden scenes that really showcase your horticultural expertise.

Composition simply means balancing the subject of each scene with attractive but uncluttered surroundings. A vivid close-up of an orchid, for example, can be weakened by a busy background of garden tools or other out-of-place items. Focus on one subject at a time, and spend a few moments looking over the image in your viewfinder. If you see background clutter, it will appear in your photos unless you change position to remove it. Sometimes, a step to the left or right is all that's needed to eliminate a distracting background.

Most important, however, is moving in close to the plant or flower you wish to photograph. If you use an SLR camera, a standard 50mm lens enables you to move

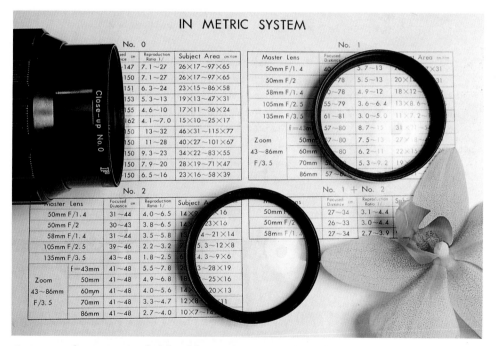

Screw-in lenses attach like filters to permit close focusing. Detailed charts may be provided by the manufacturer to show the area covered with various combinations of camera lenses and close-up attachments.

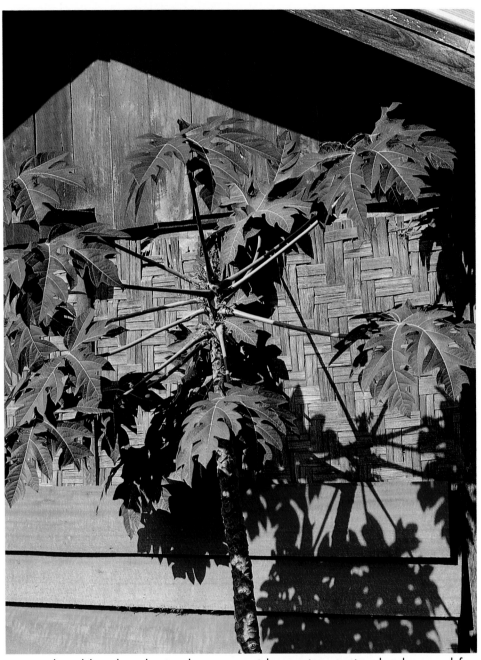

A wood and bamboo lattice house provides an interesting background for
this papaya tree photographed in Sumatra.
The shadows add interesting details.

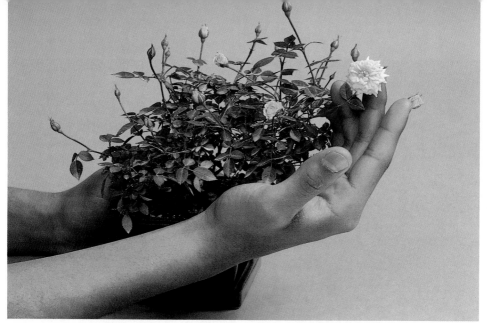

The inclusion of the hand in this photograph
provides proportion for the miniature rose 'Littlest Angel'.

within a foot or two of the subject. To-day's non-SLR compact cameras let you get within four or five feet of a subject. Many backyard photographers capture striking images of insects and small animals by getting as close as possible. Close-ups also allow you to emphasize the vibrant and contrasting colors of a garden that may not seem as dramatic from a distance. Don't let your camera distance you from your flowers.

In fact, to assure that you make the most of your photo opportunities, you may want a view of your plants and flowers as they appear through a close-up lens. Close-up lenses, which adapt easily to most SLR cameras, are relatively inexpensive and simple to use.

Close-up lenses fit over the camera lens in the same manner that a filter is placed onto your camera and will allow you to get as close as one and a half to two feet from the subject. For most conditions, you will not have to adjust exposure, which makes using close-up lenses an easy way of expanding your photo-graphic experience and adding fascinating images to your garden collection.

Another advantage to using close-up lenses with your SLR is that focusing and framing is the same as with normal distances. However, if you are using a rangefinder camera you will have to take extreme care when measuring the subject distance. You will also have to correct the framing for parallax. (Parallax, which occurs in rangefinder and twin lens reflex (TLR) cameras, is the difference between the image which appears in the viewfinder and the image that is actually exposed. It can be corrected very simply by tilting the camera in the direction of the viewfinder. Some rangefinders and TLRs come with a visual close-up frame within the viewfinder, while others do not correct this photographic error. Photographers must be keenly aware of this visual discrepancy when capturing closeup images). That is why a single lens reflex design is best for close-ups of small subjects.

Another variable that will come into play when using a close-up lens is the

These two portraits of tropical *Heliconia rostrata* make different statements, thanks to the background. Plain black puts all attention to the dramatic pendent inflorescence. Diffuse front and direct back lighting reveal all aspects of the subject. A slightly close view with the same type of lighting makes a different impression thanks to the background of a bark painting from an Amazon tribe.

very shallow range of focus—depth of field—that will be available. If you want to increase the depth of field use the smallest lens opening that lighting conditions will allow.

Many other factors also affect close-up photography. For instance, when you are extremely close to your subject, beware of even the slightest breeze which can sway a flower enough to cause a blurred image. And, in general, photographers must be careful not to shake the camera. Therefore, get as close to the subject as necessary. Be certain you have a steady stance. Many photographers find a tripod useful in preventing unwanted camera shake.

If you want to show the detail of a tulip's pistil and stamen, aim straight down on the flower to see past its petals. If you're undecided as to the best angle to use, try several positions and then select the best one from the finished prints.

The angle and amount of light in your garden photos is a matter of taste and experimentation. When photographing plants and flowers, their natural colors, textures and shapes lend themselves to filling a frame with captivating images. You can capture these challenging images best if you take your photos when there's plenty of daylight to fully illuminate your flowers.

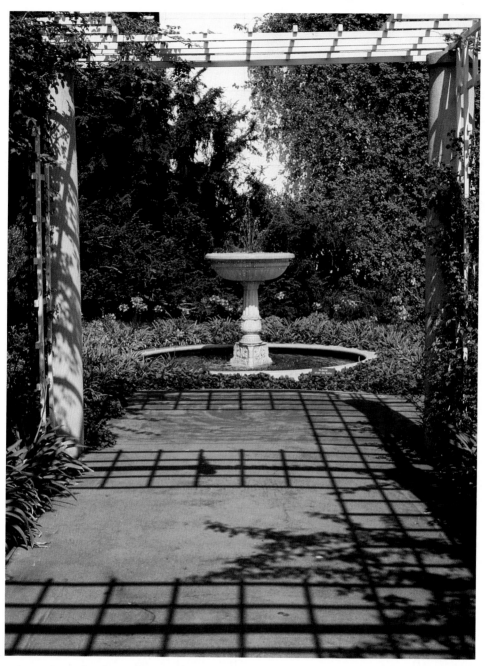

The arbor shadows frame the distant white fountain and the rose garden
at Huntington Botanical Garden in California.

Include people in garden photos. The subject inspects a cold frame.

If you visit a greenhouse or conservatory, you'll have additional challenges to consider. Lighting is usually softer inside these structures, so a "fast" color film, with a higher ISO rating, can be useful alternative to an electronic flash. Kodacolor Gold 400 is highly effective in subdued lighting situations.

You need not restrict your garden photography efforts to sunny days. Early or late in the day, the sun is low in the sky and provides interesting highlights and shadows which allow for more artistic scenes. For example, sidelighting or backlighting can emphasize shapes and patterns that frontlighting can obscure. Sidelighting is particularly effective in emphasizing the textures of flowers and plants, while backlighting will draw attention to their translucent quality. Again, experiment with placing yourself at different angles to vary the angle of light on your subject.

With the sun at your back, avoid having your shadow or those of nearby struc-

tures become part of your photo. Again, a step to the left or right may prevent shadows from inadvertently darkening your pictures.

Because many cameras are now equipped with a built-in flash, you have the convenience of adding more light to accentuate garden images. When shade has partly hidden a flower, a flash can bring out details that would otherwise be missing.

Using People, Places and Things

Photographic interpretations of your garden occasionally may require some ingenuity on your part. Simple household items can be used to help create a different mood in your pictures. For example, if you want a photograph to capture the image of a leaf or petal sprinkled with dew, spray a few drops of water on them using an ordinary pump spray bottle.

To help brighten a scene with a small plant, use a small piece of white paper or a white envelope as a reflector. Simply position it close to the flower or plant you wish to photograph (but outside of the picture), and it will reflect daylight or the burst from your flash.

In creating a photographic image, remember that you can control much of the setting and surroundings. An easy way to stage an interesting scene is with people. Children and flowers are always a winning combination; a photo that shows a freckled-faced child giggling as a dandelion tickles her nose is simple but precious. Keep in mind that your garden is for human enjoyment; use your camera to capture those moments when people are appreciating it.

Camera Care

Planning is important to good photography, but so is keeping your camera and film ready for picture-taking. Kodak experts suggest you get in the habit of treat-

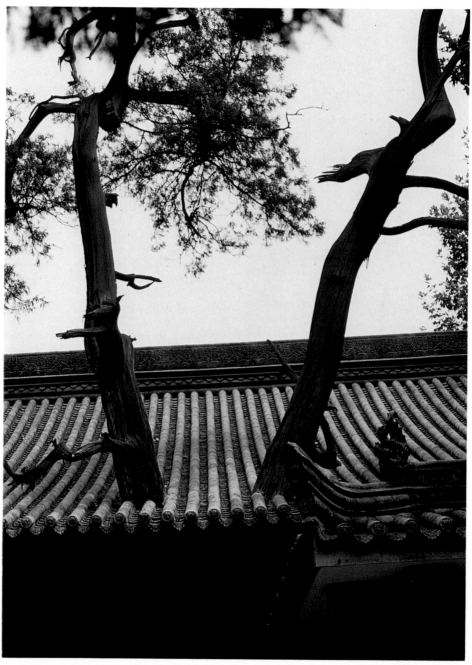

Look for interesting details that may be revealing. Here a venerated cedar grows through a Qing Dynasty Confucian temple in Xian, China.

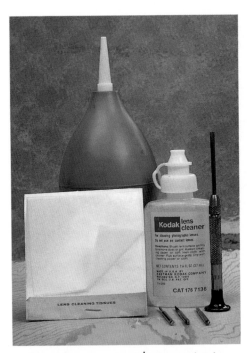

Here are some aids to assist in keeping your camera clean: a rubber air blower, lens cleaning tissue, lens cleaning fluid and a small screwdriver set (to tighten loose screws).

dust, but periodically cleaning the camera's innards with a soft lens brush is usually enough.

Remember, too, that only a few cameras are water-resistant. If you plan to use your camera on rainy days, use a transparent plastic bag large enough to hold the camera; position it so the open end of the bag does not block the lens. You can work the shutter and other controls from outside the bag.

For a day at a botanical garden or flower show, pack an "emergency kit" that can prolong your picture-taking pleasure. Include spare batteries for both the camera and its flash; an extra roll or two of film; lens tissue and a camel's hair brush to clean the camera, if needed; a waterproof bag for unexpected showers, and a notepad and pencil to jot down names and locations of various plants and flowers.

When you finish a day of picture taking, give your camera a rest, too. Release the shutter to relax the mechanism. Remove the batteries when storing your camera for an extended period. When reinstalling them, check the contacts in the battery compartment; if they're dirty, use a pencil eraser to remove any corrosion.

Remember that extreme heat or cold may affect a camera's operation, so avoid placing it in a car's glove compartment or trunk for long periods. In warm weather, a car becomes a greenhouse, and high temperatures can affect any camera. Store yours safely.

Common sense camera care has its place, but most of today's cameras need expert attention when problems develop. In these cases, ask a qualified service shop to examine your camera. Professionals can check a camera's working parts and its lens and test it for light leaks.

The best advice in camera care is not to shelve your camera for very long. A

ing your camera with tender loving care.

Start with camera cleanliness; it's a critical part of photography. For example, if the lens of your camera becomes dirty, clean it with a drop of a lens-cleaning solution on a folded camera lens tissue. Never use eyeglass tissue or cleanser since they may remove the delicate lens coating. Also, keep your fingers away from the lens surface. Use photographic lens paper rather than ordinary tissue, handkerchiefs, shirttails or other potentially abrasive cloths.

Camera interiors can be susceptible to dust, which can also blemish prints. Photographers use many methods to remove

camera that isn't taking any pictures collects dust, not memorable photos.

Film Care

Proper film-handling begins as soon as you purchase a roll of film. Again, do not store film in a car's glove compartment on a hot, sunny day. Instead, keep it in a cool, dry place, away from sunlight or other heat sources. Use the film before the expiration date printed on the box. Once you open the package, try to use the film in the next couple of days.

Many cameras automatically load film by advancing a roll to its first frame when you close the film door. With others, you thread the film on a take-up spool by hand. In either case, find a shady or darkened area for loading to avoid accidental fogging.

Use the film box top to remind you of the type of film and number of exposures on the roll. Tuck it in a pocket or under the buckle of your camera's neck strap as a reminder. On some cameras, this data appears on the film cassette and is visible through a window on the camera body. Other cameras have a rear slot designed to hold a film box top; remember to change it each time you switch to a different speed or type of film.

Whether your picture-taking leads you to a public garden or your own backyard, carry extra film. When you have an idea for a photo, it is frustrating to run out of film. Here's where the extra film in your "emergency kit" comes in handy.

Finishing Touches

Success in garden photography is measured by more than a set of finished prints. The images of flowers or plants you collect with a camera are unique; they are interpreted on film with a one-of-a-kind vision of your garden. In floral photography, your only limitation is your imagination. Be creative, and use your

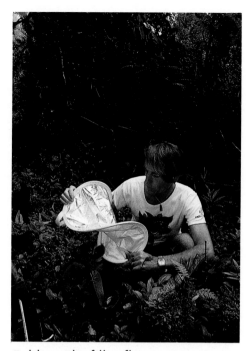

Folding Flexfill reflector twists open to form lightweight reflector, here being prepared by photographer to bounce light into terrestrial orchids in a Central American cloud forest.

knowledge of flora as a stepping stone to experimentation.

The most effective way to expand your horizons is by practicing picture-taking whenever time and circumstances allow. A camera loaded with a fresh roll of film offers endless photo opportunities, waiting to be explored. By photographing flowers and plants at various times of the day and during various stages of growth, you can enjoy chronicling the development of your skills as both a gardener and a photographer. You will find your confidence in picture taking growing as rapidly as your healthiest plant or flower. 📷

(Note: Kodak and Kodacolor Gold are trademarks.)

Understanding Equipment:
TEST FULLY!

Charles Marden Fitch

For more than 25 years I have used a succession of Nikon single lens reflex cameras. Each new model has had slight improvements over older designs but the basic mechanical operations remained similar. It was not really necessary to re-learn how to operate each new model.

This changed when computer-controlled automatic features were introduced. All major camera manufacturers now use sophisticated programming devices in their advanced designs. My newest Nikon has a 100+ page instruction book. Such texts are required reading if you want to fully exploit and control all the useful features.

Test Fully

When you begin using new equipment, expose a few test rolls of the same type of film you plan to use later. Keep notes as you go. Test all features of your camera, flash, and accessories, referring to the instruction books for recommended manipulations. Keep your test slides or prints in a notebook for future reference.

Automation

Modern automatic controls can provide perfect exposure of average subjects and a specific film but they can only provide optimum artistic quality if you (the photographer) direct controls for depth of field and motion-stopping shutter speeds.

The most sophisticated computer-controlled camera still depends upon you to decide if a flower's swaying in the wind should be stopped to freeze the view (fast shutter speed) or if the movement in the wind should be visualized to record a blur of color (slow shutter speed). With many cameras and flash you can actually get BOTH effects on one frame, if you know how to use combinations of slow shutter speeds with electronic flash.

Similarly you must decide how deep the zone of focus (depth of field) should be. For example consider photographing a garden bed. Do you want only the front row of flowers really sharp? ... or do you prefer that the whole border plus everything behind and in front be sharp? You must program/control/ manipulate the camera to use a small iris opening for maximum depth of field, or to expose with a wide open iris for minimum depth of field.

Symbolic Help

Modern cameras from Japan are labeled with symbols to help you understand multiple features. Here are the most popular symbols, created by the Japan Machinery Design Center and used by the major manufacturers.

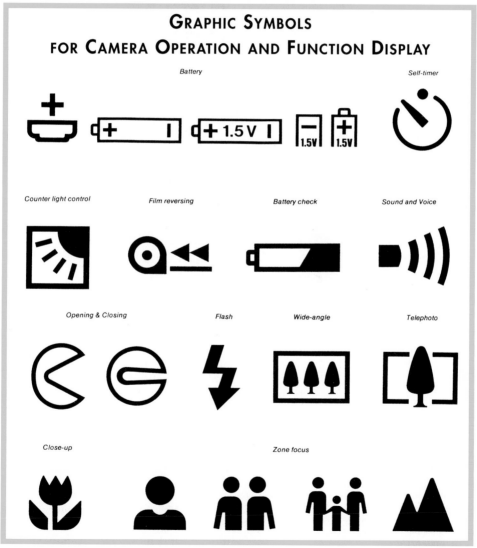

GRAPHIC SYMBOLS
FOR CAMERA OPERATION AND FUNCTION DISPLAY

Battery

Self-timer

Counter light control

Film reversing

Battery check

Sound and Voice

Opening & Closing

Flash

Wide-angle

Telephoto

Close-up

Zone focus

SYMBOL DRAWINGS COURTESY OF
THE JAPAN MACHINERY DESIGN CENTER

PHOTOGRAPHING GARDENS

ARTHUR HELLYER

Include a hint of background in your location garden photos.
Here a clump of cymbidum orchids grows on a tree at the former home of
Ho Chi Minh in Hanoi, Vietnam.

I use a camera for two purposes: to provide pictures for reproduction and as a permanent record of gardens I have visited and plants I have admired. If I have to write about these gardens or plants, the pictures are a valuable supplement to the notes I have

ARTHUR HELLYER *is gardening correspondent for the* **Financial Times**, *London. He was editor of* **Amateur Gardening** *from 1946-67 and is a contributor to* **Country Life** *and* **Homes and Gardens**. *He is also author of* **The Amateur Gardener** *and* **The Shell Guide to Gardens**.

made about them — frequently revealing features that I had forgotten or not even fully appreciated at the time. Because of this dual purpose, I usually take a lot of pictures. Some of them are carefully composed to look beautiful when reproduced but many are taken with the sole objective of recording the character of the plants or the design of the garden.

Because I need an accurate record, I photograph everything in color and because I usually require a lot of pictures in quite a short time, I use a 35mm camera

24

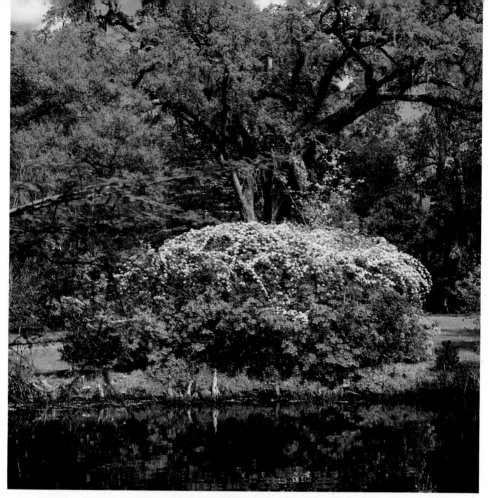

Magnolia Plantation and Gardens in Charleston, North Carolina was founded in the late 1600s, so plantings are exceptionally mature. Shown here are masses of azaleas and roses under towering live oak trees — a photographers paradise.

with through-the-lens light metering. Also for economy of time I seldom use a tripod. This does sometimes result in some loss of quality but by using moderately fast film and cutting exposures whenever possible to something less than 1/100 sec I do reduce the effect of hand shaking to a minimum. When faced with bad light that makes such short exposures impossible, I look for some convenient prop to steady my body and arms. Sometimes it can be found against a wall or tree, sometimes by kneeling, squatting or even lying on the ground. By such simple means I have even succeeded in taking tolerably good pictures at exposures of 1/8 sec although when conditions are that bad it is better to use a tripod.

It is much easier to photograph gardens or plants in color than in black and white since color involves no mental transposition from what one actually sees. This problem is far more acute with plants than it is with buildings. Reduced to monochrome the colors of flowers and of leaves behave in the most unpredictable

ways. I have noticed that even the greatest experts can go hopelessly astray.

Color does give some problems but they are not as numerous as those of monochrome photography. Variables include the film, the quality of the light and the color of the plant which film rarely records in quite the same way as the human eye. Most strong reds suffer in bright sunlight and are best photographed outdoors when the sky is a little overcast. Blues can be most unpredictable and it seems almost impossible to capture some blues on film no matter what one does. A notable example is *Stokesia cyanea*, a hardy plant with blue, cornflowerlike flowers which almost invariably become lilac-pink in a photograph. No doubt this could be rectified by the use of filters.

When photographing gardens it is necessary to use fairly wide-angle lenses whereas for individual plants, and even more for close-ups of flowers, a moderately long focus lens is preferable. For years I made use of several lenses in the belief

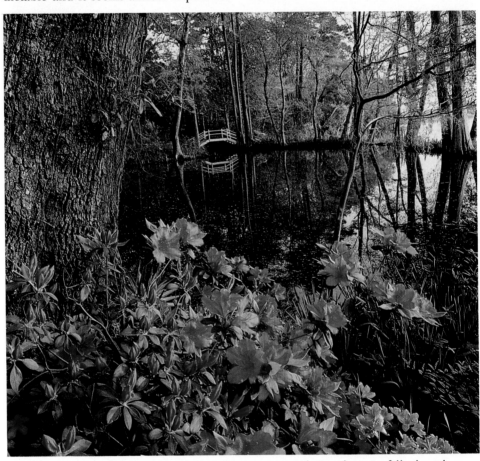

Another scene from Magnolia Plantation and Gardens is filled with a mass of azaleas, water and graceful bridge that attracts the eye to the background.

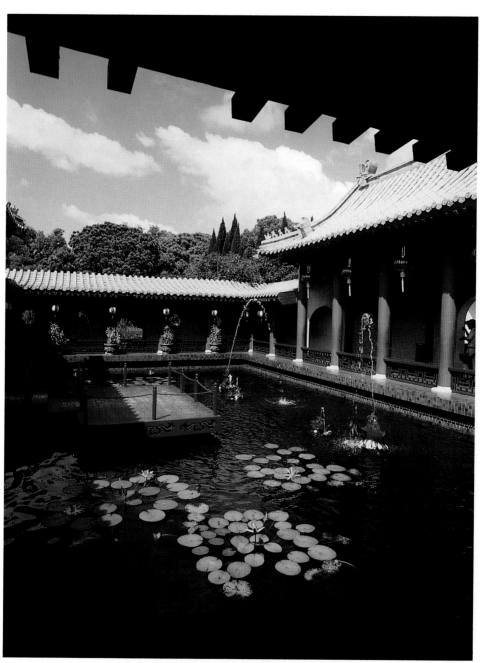

This lily pond in a Singapore garden
is dramatically framed with the
Chinese pavillion.

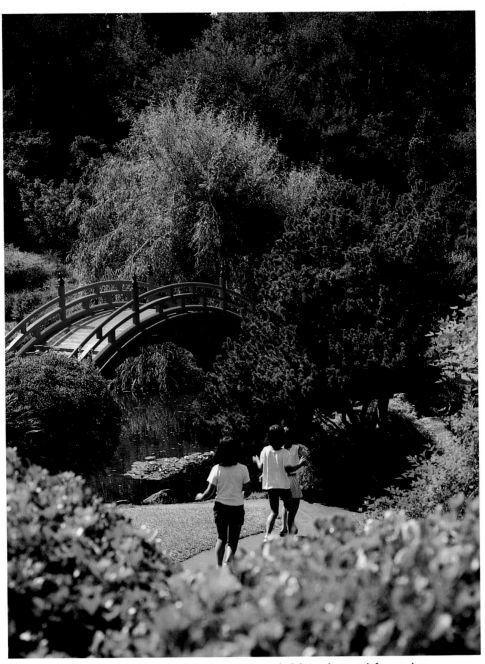

A bright red bridge and running children bring life to this
Japanese landscape at Huntington Gardens, California.

Ficus seedling sprouts in temple wall, Thailand.

that the available zoom lenses gave insufficiently sharp images throughout their focal length. Maybe this was always an unjustified prejudice or perhaps the lens makers have improved their formula. The fact is that, since I purchased a zoom lens with a range from 35 to 70mm, the miscellaneous fixed focal length lenses have lain almost unused in my bag. Only occasionally do I reach for the 28mm lens to deal with a particularly confined space or a telephoto lens to capture something I cannot approach closely.

Composition is an individual matter. I like to keep foregrounds reasonably full and sometimes this is the biggest problem since garden makers never design their gardens for the benefit of photographers. The human eye makes compensations and relates one thing to another in a way that is quite impossible for the inanimate camera. Yet by wandering around and looking for conveniently placed beds, shrubs, trees, ornaments and buildings, a satisfactory solution can usually be found.

Spring azalea photographed to show the plant's location
next to a swamp in South Carolina.
The water provides a pleasing background.

The greatest difficulty to outdoor photography is the weather. Full-time photographers may be able to wait for days or to return to their chosen site when the weather and light prospects are most favorable. My work, primarily as a writer and only secondarily as a photographer, almost completely precludes such latitude. I must visit a garden on an appointed day and get on with the task of recording it with pen and camera even if it rains all day. Even a cloudless sky can present problems since it can be almost as uninspiring as one that is totally covered with cloud. The ideal is the mixture of blue and white that can be produced by anything from almost static cumulus to scurrying cirrus. Yet these can also be the most time-consuming days as one stands impatiently waiting for the shafts of sunlight to illuminate the important features of the composition and the background sky to hold a reasonable mixture of blue and white. One can learn a lot about cloud formation on days like that and results can be rewarding.

A moderate wide angle lens was needed to get the graceful upward sweep for this view of the Chinese Garden entrance in Singapore. By waiting for a person to cross the bride, left center, photographer Fitch was able to provide a warmer feeling for his landscape.

The difficulty with public gardens is the visitors. Of course it depends on what one is looking for. Sometimes the animated scene is just right. The vast terraces of Versailles were conceived as stages on which the king and his courtiers could parade. If one cannot have them, at least a medley of gaily clad tourists may provide a tolerable substitute. But there are also gardens created for solitude. At Studley Royal and Stourhead, for example, any intrusion on the peace of Arcadia is intolerable. Patience is the only solution, allied with a promptness in taking the picture the moment one group of intruders disappears and the next arrives. Occasionally people are sympathetic to photographers and will wait a moment when they see the camera raised. More often they are totally oblivious, taking up a position in the foreground and continuing to chatter for what seems an eternity. No wonder a professional garden photographer once told me that he found his work very hard on the nerves.

31

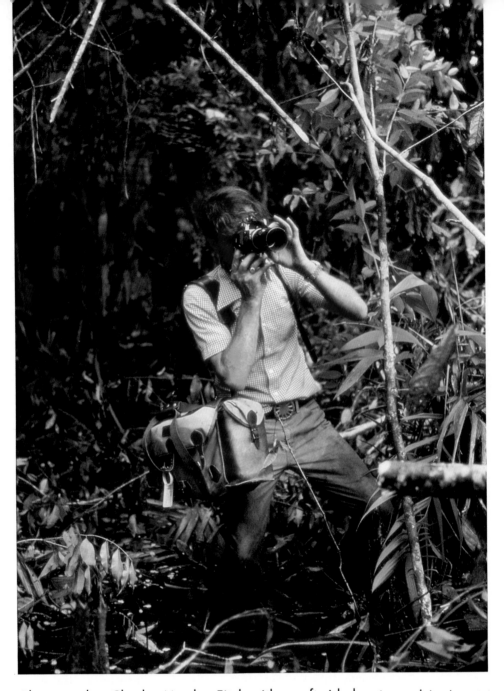

Photographer Charles Marden Fitch with a soft sided water resistant case
protecting his equipment in a wet Malaysian jungle.
Inside the soft case plastic bags and air cell plastic sheets provide further
protection for delicate lenses. PHOTO BY MICHAEL H. C.OOI

COPING WITH CHALLENGING LOCATIONS

CHARLES MARDEN FITCH

Location is the word professional photographers use to identify work away from the controls and comforts of a *studio*. A den, greenhouse or patio may be the studio; a distant garden or exotic jungle the challenging location.

Creating photographs in unfamiliar or trying locations requires effort. Turning out artistically satisfying or scientifically useful photos under less-than-ideal conditions is an even greater challenge. What are some techniques that will help you with photography on location? The most important technique is planning.

Goals

Have a clear goal for each photography event. Know how you want to use your photographs. Some common categories of use include:

❶ Slides for teaching or publication
❷ Prints for a scrapbook
❸ Slides or prints for scientific records
❹ Light controls
❺ Artistically satisfying photographs for display prints

Knowing how your photographs will be used is one step toward selecting appropriate:

❶ Film
❷ Camera
❸ Lenses
❹ Light controls
❺ Accessories

Conditions

Under what conditions must you take the photographs? A mismatch of film to conditions, or camera/lens to available light can be a disaster. Once while on a trip in Uganda I took a boat ride down the Victoria Nile. I was busy photographing habitat vegetation and sunbathing crocodiles until a fellow traveler interrupted me with questions.

"How can you get any good shots from this moving boat when it's cloudy?" he asked. He was finding it impossible to get a suitable exposure reading with his excellent camera and lens so I asked "What film are you using?". "Oh, the camera store owner told me Kodachrome-25 was the best slide film so that's what's in my camera."

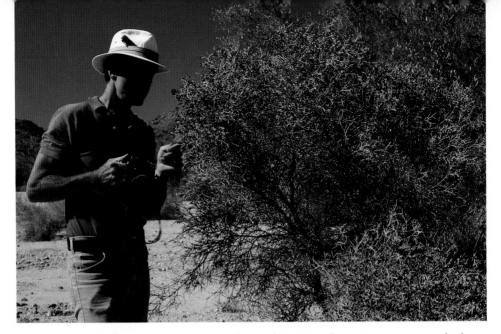

It is a good idea to wear a hat when photographing in strong sunlight. Charles Marden Fitch prepares to photograph a smoke bush in its desert habitat. The hat provides protection from sunstroke plus shade for easier viewing.

Without knowledge of his customer's location conditions the camera store owner had identified Kodachrome-25 as the "best color slide film." Kodachrome-25 is widely accepted by professionals as an excellent fine-grain film with saturated true colors but it's not the *best* choice for photographing from a moving boat, on a cloudy day, with a handheld f/4.5 telephoto lens.

Preplan

With better planning that disappointed photographer would have had success on his Nile adventure. For example he should have known that:

❶ A f/4.5 lens lets in only a moderate quantity of light.

❷ Africa has cloudy weather in the rainy season.

❸ Photographing with long telephoto lenses from moving boats requires fast shutter speeds for sharp results.

❹ Small flash units are usually ineffective for distant subjects.

With these facts in his preplanning file, he would have asked his camera store friend for a slide film suitable under conditions noted above [for example an ISO 200 to 400 film]. Asking only for "the best slide film" got him into trouble. Here are some suggestions and techniques for successful plant photography on location, especially during travel.

Basics

To understand why your plans should include such specific choices, remember the basics. Correct exposure for any light-sensitive film is delivered by the interaction of two mechanical camera parts;

❶ The size of the lens opening, called f/stop, iris, or aperture.

❷ The speed of the shutter, i.e. how long the light (the image) falls on the film.

Even automatic cameras depend on these two mechanical aspects (aperture and shutter) to deliver correct film exposure.

Sharpness

❶ To get sharp results the subject must be still in relation to the film. An image moving across the film will register with varying degrees of blur. Moving subjects require faster shutter speeds to record clearly than do stationary objects.

Cameras moved during exposure can also contribute to blurry pictures. To avoid camera/photographer jiggle, magnified by telephoto lenses or by macro lenses used for close-ups, use faster shutter speeds.

❷ The zone of sharpness, in front of and behind your point of focus, increases as the lens aperture becomes smaller. For example, you wish to photograph a flowering ginger outdoors in Hawaii. The plant is three feet away. You focus at three feet. Behind the flowers at 20 feet is a house, closer to the camera at one foot away is a palm frond.

If you take this picture using a large lens aperture, almost fully open iris, only the ginger flowers (where you focused) will be truly sharp. If you take the same photo using a small aperture, an iris closed down to a tiny opening, acceptable sharpness will extend from the palm frond to the house and beyond. The zone of sharpness, called depth of field, is a useful artistic control for photographers.

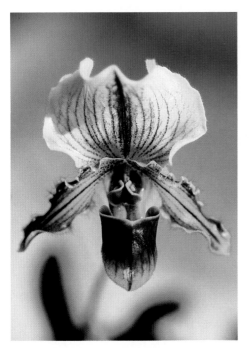 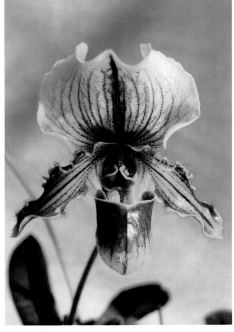

The zone of sharpness, called depth of field, becomes greater with small iris openings (f/stops). A very large opening such as f/4.5 offers shallow depth of field (above left) while a small iris of f/22 provides enough depth of field to render the whole complex *Paphiopedilum* sharply.

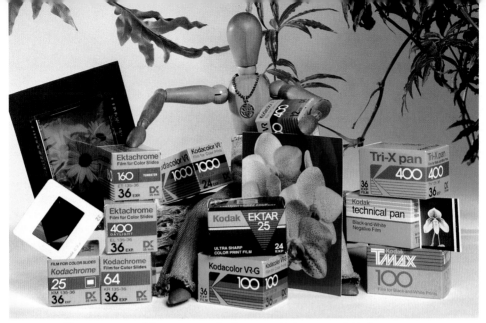

Choose your film to match the conditions and light source.
These films offer a choice of light sensitivities (ISO ratings),
slides or prints, color or black and white.

Light

The intensity of light is important in planning your photography. Bright light gives you more possible choices for manipulating depth of field than dim light. Shutter speed and lens aperture work together controlling exposure. With dim light the iris must be open more and/or the shutter speed must be slower. What does film choice have to do with your options? Film sensitivity to light, and therefore correct exposure, varies.

Film Choices

Color fidelity and smooth sharp (grainless) results decrease with a film's sensitivity to light. In general films with high light sensitivity (high ISO numbers) cost more than less sensitive films. High sensitivity (called high speed) films show more grain and less true colors than low to

*ISO has replaced ASA and stands for International Standard Organization while ASA stands for American Standard Association.

moderately sensitive films. For the lowest cost and best overall results use the lowest ISO film compatible with conditions.

For natural light photography use Kodachrome 64 rather than Kodachrome 200 or Ektachrome 400 when subjects are still and you have bright light. Choose fast Ektachrome 100 (slides) or even more light-sensitive Kodacolor 1000 (prints) to capture subjects in low light, windy locations, or with long telephoto lenses.

Negative film, color or black and white, is more forgiving of over or underexposure than slide film. For example, you can underexpose or overexpose Kodacolor film by two stops (iris openings or shutter speed positions) and still get acceptable prints.

With a slide film such as Kodachrome a one-stop exposure error is about the limit for acceptable results. Bottom line: Use negative film if you don't need slides. A professional lab can make excellent slides from color negatives if you later need some for projection.

Publishers prefer transparencies for publication so slide film must be your choice if the photographs are needed for print media. Slides are also best for lectures. Excellent prints can be made from slide film.

Color Personality

Films have a color personality easiest to see in color slides. Color differences between negative (print) films are less dramatic because modern printing machines standardize print tones with filtration. In slide films Fujichrome 50 has electric saturated blues, perhaps just what you need to emphasize blue-toned flowers or skies in habitat views.

Ektachrome films give bluer (cooler) results than Kodachrome. Fit the film personality to your preference. Match film types to your light source or correct a mismatch with filters suggested in the film instructions.

For example, if you use daylight type color film under tungsten lights, at a flower show perhaps, use a blue color correcting filter. Electronic flash is suitable for daylight color films without a filter. Tungsten lights are suitable for tungsten light type films without a filter. Whichever film you choose keep it away from extreme heat (direct sun, storage in hot rooms or vehicles).

For field work where relative humidity is high (i.e., above 80 percent) put exposed film into plastic bags with envelopes of silica gel. Small envelopes of silica gel come packed with most imported camera and audio equipment. It is also sold by sporting goods stores. The gel helps remove moisture from the film.

At the end of each photographic day dry out the silica gel and film as conditions permit. When electricity is available you can dry out the gel over a warm light bulb or in an oven on low for 30 minutes. A portable hair dryer is also useful for quick drying of camera equipment, cases and silica gel packs.

Dry film in air under 80 degrees F. For example, a fan blowing over the film, or situating the film far away from a hair dryer set on low. Once film has been exposed to dry air for an hour (or after you have done all possible to reduce humidity around the film) return the film container to its sealed plastic film can.

Since film is damaged by excess heat

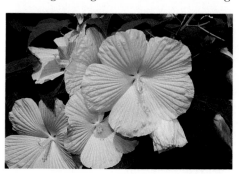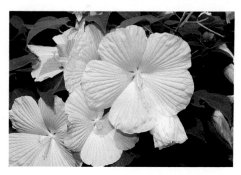

These two views of garden *Hibiscus moscheutos* 'White Giant' were taken with the same camera, film and lens, using through the lens metering. Since the white subject fills most of the frame a straight metering renders the white too gray. The second view was taken with the camera adjusted manually, to give one stop more exposure than the meter indicated off the white.

Careful attention to composition places the Wong Tai Sin Temple adjacent to the Sik Yuen Garden located in Hong Kong.

it's important to keep it cool and dry. I carry insulated zipper bags which hold twenty 35mm film cans, good for keeping temperatures under control.

Store film in a refrigerator when possible. Mail film back to a processing lab when you are in a major city. Send it from a post office or trusted hotel. It's important that your film make the trip without sitting in a hot street mailbox or car.

I use Kodalux prepaid mailing en-velopes for airmailing Kodak film to a processing lab nearest my location, or to whichever Kodalux lab will get the film first, according to international air ser-vice. Processed film will be returned to the address you write on the envelope/mailer.

Formats

A 35 millimeter format is the most practi-cal for all sorts of location plant and gar-

den photography. 35mm films are widely available in many brands, and ISO ratings. The 35mm size offers slides that fit in universally available projectors. Fine-grained 35mm films can yield large prints of excellent quality. Larger formats require larger equipment, more expensive film.

For domestic location work I may use a single lens reflex Mamiya camera which yields big two-and-one-quarter inch by two-and-three-quarter inch slides, but for field photography under tough conditions I prefer the practical 35mm format. Cameras smaller than 35mm are often less versatile than popular 35mm models and they give lower quality photographs.

Design

The single lens reflex 35mm camera is a versatile compact design well suited to field photography. I recommend a model with an interchangeable lens but even a low-priced model with a fixed lens is better suited to close-up work than a rangefinder design. With a single lens reflex you see what will record on the film. You can judge precise focus, composition and depth of field.

Lens Choice

In field photography I often want to show a plant PLUS the habitat. For these medium to wide views a normal 50mm lens, usually sold with 35mm cameras, is suitable. For frame-filling close-ups a 50mm lens must focus closer than the usual two or three feet. An inexpensive way to focus closer is to use screw-in close-up attachments that fit on front of any lens, much like a filter. A set of three such screw-in close-up lenses of varying power cost under $20.

More versatile, and giving sharper overall results, are macro lenses designed to focus from infinity to several inches. A good general-purpose macro lens is in the 50 to 55mm range. If you want to be further away from the subject choose a 90 to 105mm macro. Modern zoom lenses can deliver quality almost equal to top brand single-focal-length lenses. A zoom lens gives you in a single lens, a wide range of choices—for example, 35mm (moderate wide angle) to 100 or 150mm (moderate telephoto), plus a "macro" position on most modern zooms.

Note that the macro position on most

Match film with correct light source, or use a filter to make film and light source compatible. Here one view of a red cattleya orchid has perfect color because daylight film was used with daylight color light (a Balcar flash). The second view shows color distortion because daylight film was exposed with tungsten light, a light much redder in tone than the film should have.

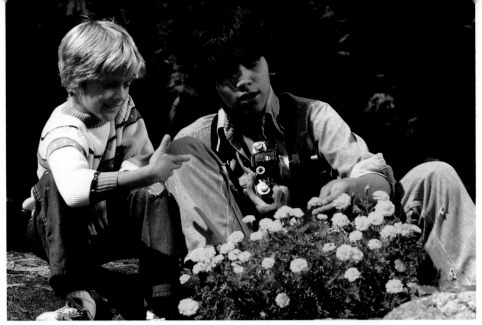

Study a garden subject to choose the best angle. Here the photographer and friend prepare to photograph marigolds with a macro lens.

zoom lenses does not permit as close a focusing distance as true macro lenses. The primary reason to use a zoom is convenience. With a zoom you have only one lens to carry for wide, medium, tele, and moderate close-ups.

A zoom is often less costly than several separate lenses. My main reasons for using single-focal-length lenses for some work are that they deliver slightly better quality, often let in more light (wider maximum aperture per dollar spent), have true macro design to fill a 35mm negative with a subject only two to three inches across.

Useful Filters

To protect equipment keep a Skylight filter on every lens. Using a $10 to $20 filter to protect a $200+ lens is good insurance. I have ruined several filters doing field photography in rough habitats, but thanks to the protective Skylights my lens elements were not damaged.

A Skylight filter is slightly pink. Al-

though the color cast is so slight that no exposure increase is needed, the filter will help remove excess blue light often found in open shade.

To increase color saturation and render blue skies a deep tone, use a polarizing filter. With black and white film the most useful filter is a yellow-green. The yellow-green renders foliage a lighter shade of gray and turns blue sky darker, making white clouds show up.

On top of every filter put a lens shade. Use a size made specifically for each lens. A lens shade (hood) keeps light off the front glass, thus eliminating the flare and distracting light patches that occur when the lens sees a direct light source.

Camera Supports

Tripods, monopods, and solid places to rest your camera for slow exposures are useful in location work. When the air is still you have the option of using slow-shutter speeds (i.e., 30th to 1 second).

With a slow-shutter speed you can use a

40

A light weight tripod used on top of a car hood provides needed support for a camera and telephoto lens.

A light weight tripod can be used as a brace. It acts to steady the camera. Here the photographer is capturing a close-up of *Aranda*, an orchid in Singapore.

Your body can form a support for your camera in areas where a tripod won't work, such as in this Thai jungle stream.

Photo by Sompong

When a tripod is not available brace your camera to keep it steady for slow exposures, as here in a Central American jungle. Photographer Fitch is using a flash to provide slight fill light in combination with a slow shutter speed using mainly available light.

smaller iris opening (f/stop) thereby increasing depth of field. Tripods also help with precise composition. When your camera is stable you have time to arrange the subject, studying all areas of the frame. For the most dramatic composition include only important elements in each view.

When doing field photography I often carry a medium-sized tripod, a smaller, lighter-weight model than I use under studio conditions. If even a medium-sized tripod is impractical to carry I bring along a 19.7 ounce model that stores at 15 inches but opens to just over 40 inches. This compact model fits in the bottom of a large camera bag or tucked into my belt.

When even this size is too much to carry I always have a folding four inch "Ultra-Pod", offered in some sporting goods catalogs. This tiny model has a ball-joint head, three legs and a self-gripping fabric strap. Once the camera is attached you can strap it to a post, tree, or use the legs. Since the legs are only four inches tall I often put this mini-pod on top of a rock, log, vehicle or camera bag.

Shutter Facts

To cope with subjects blowing in the wind use a shutter speed 250th of a second or faster. If that's not possible then use electronic flash which will "freeze" the moving subject.

When the subject is still you can make good natural-light photos with a slow-shutter speed so long as the camera is steady. When using a slow-shutter speed, release the shutter with a cable release or use the self-timer (found on most modern 35mm cameras). Just pushing down on the shutter release often causes slight camera movement leading to blur at slow-shutter speeds. A cable release is much softer than finger pressure. Using a self-timer gives eight to ten seconds elapsed time between manual shutter release and the actual exposure.

Light Control

Portable electronic flash is a versatile light source for location work in the field or at flower shows. Modern units are automatic under most conditions. Some camera/flash combinations can determine correct exposure at the film plane. Even low-priced clip-on (hot shoe) models offer auto intensity control over a range of two or three feet to 20 or 30 feet. Electronic flash is the best way to cope with moving subjects and low light.

If direct flash is too harsh for your artistic goal, diffuse the light. Diffusion materials (domes, screens, fabrics) are available for many popular flash models. Using a white card or silver reflector on the side opposite your flash will fill in dark shadows. See the feature "Open Shadows, Wrap-Around Light" for more details.

A general goal in handling light for plant portraits is to reduce extremes in contrast. A ratio of two or three iris openings between shadows and highlights is the practical range for good quality prints and slides. When light is very contrasty you can get better photos by filling in the shadows (reflectors or flash) or by reducing the harsh light with diffusion material.

For natural-light color photography the best conditions are cloudy-bright. When the sun is just hidden behind misty clouds, shadows are open yet colors are still bright. Ring-light flash units give a result similar to cloudy-bright days. The ring-light flash has a circular tube that fits around the lens.

Ring-lights deliver even, flat light. More complex ring-lights have two, three or four separate tubes inside the housing. Each tube can be controlled individually. By having one brighter than the other, or one tube off but three on, the quality of illumination is more three-dimensional, not so flat.

Accessories

Photography under adverse conditions (rain, dust, mud, fog) is easier with a few small accessories. For example here is a list of a few helpful items I carry for field and travel photography:

Protective case for camera and lenses (shoulder bag or pack)

Batteries (extra) for camera and flash

Cleaning tools (air blower, lens tissue, lens cleaner)

Small set of screwdrivers

Flashlight

Plastic bags big enough to cover camera cases

Insect repellent

Knife with many blades and tools (i.e., Swiss army type)

Drugs to treat fire ant and bee stings

Moist towelettes in foil envelopes

Reflector foil (Rosco Fetherflex silver material)

Insulated bag to keep film cool

Extra lens caps (front and back)

Notebook and pens

For remote locations add: water purification tablets, maps, compass and similar field-work equipment that you would want even if photography where not a goal.

Many of the methods described here are based on my work in the tropics since most indoor plants come from tropical habitats. However the basic recommendations for location photography are just as useful for capturing a native species in your local nature reserve or prize specimens at a flower show. 📷

TEXT BASED ON A FEATURE ORIGINALLY APPEARING IN THE AMERICAN ORCHID SOCIETY BULLETIN.

Tovah Martin prepares her plant subject at Logee's Greenhouses. The black cloth hood makes precise focusing easier in the bright greenhouse situation. The sturdy tripod permits slow exposures.

PHOTOGRAPHY UNDER GLASS

TOVAH MARTIN

Who can resist the urge to photograph in a greenhouse? Everything looks great under glass. Protected from the nibblings of insects, sheltered from scorching sun and beating rain, plants are prime indoors.

Greenhouse photography has advantages as well as drawbacks compared to shooting in the outdoors. During winter, a greenhouse is the only place where nature is in full flower despite the weather outside. Ardent plant photographers have no choice but to turn their lenses toward the things growing inside. But, in summer, many photographers

TOVAH MARTIN *is the staff horticulturist at Logee's Greenhouses of Danielson, CT. When she isn't answering houseplant questions, she is busy photographing for Logee's color mail-order catalogue. Her first garden book,* **Once Upon a Windowsill***, was recently published by Timber Press.*

still opt to keep their cameras under glass rather than battling the elements outdoors. Although I'm always tempted to set up outside in midsummer, I usually stay indoors.

Wind is the factor that always convinces me that the shooting is better indoors. A little breeze can ruin a close-up, a faint wind can send my background crashing on top of a painstakingly arranged set-up. In a greenhouse, the photographer has complete control over air movement. You can easily turn off fans while shooting — you will probably swelter, but leaves and flowers will remain perfectly still. Some of the sharpest pictures are shot under glass.

I also prefer the filtered light in a greenhouse compared to the sun's harsh rays. Greenhouse light is subdued, causing colors to glisten. Of course, the quality of greenhouse light depends on

the type of structure in question. Plastic greenhouse tend to shed a yellow cast on white flowers while making glossy green leaves appear pale yellow. Acrylic houses lend a crisp, pure tone to photographs and clean glass houses make colors sparkle. The time of day also has an effect. Early morning sun rays usually look yellow on film and evening light often appears bluish when filtered through greenhouses. Noonday sun gives the truest colors.

The old adage warning against photographing flowers in full sun doesn't hold true in a greenhouse. Go ahead and shoot in full sun — if you can endure the sun's heat magnified under glass. It's a sweaty job — but you'll probably get better pictures than you ever accomplished outdoors.

If you shoot on a bright day, you won't need lights under glass. A flash is only necessary to provide "filler light" to enhance the center of a tubular blossom or encourage a dark flower to pop out from its background. Natural light is usually sufficient in late winter, spring and summer. In autumn and midwinter, you might have problems with low-light levels. Try using faster film, a tripod and timing for noon daylight to solve your troubles. In any light, a tripod is essential for photographing in the greenhouse.

One of the greatest advantages of photographing in a greenhouse is the absence of shadows. When filtered through glass or plastic, light is diffused and falls softly and evenly on plants. You are saved from those deadly dark spots that creep into a camera's vision but are rarely noticed by the human eye. Under glass, glaring reflection from shiny surfaces (such as leaves) are avoided. If your light is coming from only one direction, or if you want to illuminate the background of a shot, use a reflective screen. There are all sorts of reflectors available,

but a sheet of cardboard covered with aluminum foil does the trick cheaply and efficiently.

Although greenhouses solve many light problems, they also pose dilemmas that do not normally plague outdoor photographers. For example, an indoor photographer has to grapple with the pipes, benches and vents of the greenhouse framework. Even when the structure doesn't get into the picture, it can cause uneven light.

There are all sorts of opportunities for a photographer under glass. Sometimes a greenhouse photographer simply wants to document the color of a flower. A quick close-up will suffice. More often, a proud grower wishes to snap a permanent record of some beautiful specimen that he or she has been coddling for several years. The greenhouse is a great place to take plant portraits.

Plant portraits pose a unique set of challenges compared to close-up work. Before you start, scrutinize your botanical model with a critical eye. Every leaf and flower must look perfect. When something is amiss in a photograph, it stands out.

Next, consider the location. Find a spot with even light and minimal shadows. Think about the set-up. One of a greenhouse photographer's biggest headaches comes from grappling with a crowd of competing plants. Group shots taken in a greenhouse are rarely successful unless subjects are segregated into a small cluster.

Also consider the scene behind the plant. Occasionally, it is possible to put the background out of focus until it looks like a confetti of colors. But, that technique becomes more difficult when you have a large plant to photograph. A backdrop is often necessary to focus attention on the subject and delete upstaging debris in the background. I

frequently use a backdrop for close-ups, and I almost always use one when taking portraits of full plants.

Artist's posterboard or rolls of seamless background work well, especially if you put the backdrop far away. I usually use blues (pale blue looks like sky at a distance), greens and black. It's wise to choose a muted color that picks up some hue in the flower. Complementary colors occasionally work, but they usually look too contrived. When in doubt, use black. Always select a non-glossy background that won't bounce light back into your lens.

If possible, put the backdrop in the shadows and let the flower or plant sit in the sun's spotlight. Granted, it's an aggravating and time-consuming ordeal to arrange plants, select a matching backdrop and simultaneously prop the cardboard so it doesn't come crashing down. But the results generally compensate for the effort. A staged shooting can easily take hours — before you start setting up, make sure that the sun is going to stay with you for a little while.

In addition to a camera, a tripod, a backdrop and a botanical subject, I use a handful of other, nonessential, items. I work with a handheld light meter, a black sheet of fabric covering my head and the viewfinder to cut off stray light, and a lens shade to eliminate glare on the lens glass. Although these items are not necessary, they are always helpful.

Finally, before actually taking light readings and figuring exposures, primp your model. Pots should be washed clean before shooting, leaves must be wiped and the plant has to be spruced until it looks perfect. Now you're ready to shoot. Take a few exposures at different settings — you won't want to repeat the setting-up process again.

Practice makes perfect. And greenhouse photography becomes easier as you gain experience. With time and practice, you'll choose favorite shooting locations in your greenhouse and you'll learn which time of day brings the best light. And yet, the beauty of photography lies in the fact that every picture poses unique challenges. Expect the unexpected — sometimes the results are wonderful. 📷

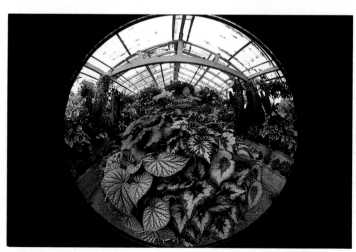

An 8mm fish-eye lens captures the greenhouse and begonia display at the Royal Botanic Gardens in Kandy, Sri Lanka.

PROFESSIONAL TECHNIQUES ILLUSTRATED

CHARLES MARDEN FITCH

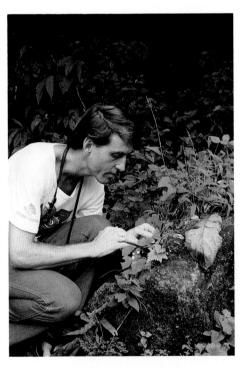

The difference between professionally created photographs and snapshots is often a matter of concentration. Professional photographers and artistically oriented amateurs take the time to concentrate on precise techniques that lead to tight composition, sharp focus, dramatic close-ups.

Tools that help produce professional results are available at fair prices. These include versatile single lens reflex cameras, a wide selection of sharp lenses, many tripod designs, reflector and flash units, from tiny clip-ons to powerful studio strobes.

All these mechanical items contribute to success when they are used in appropriate situations by sensitive photographers. This handbook provides many suggestions for capturing plants and gardens on film. The following photographs show some of the techniques used by professionals to produce dramatic informative photographs.

Charles Marden Fitch prepares to photograph a begonia in its Sumatran jungle habitat. Even in formal garden settings it's useful to clear away distracting leaves or twigs that cast shadows or hide important details.

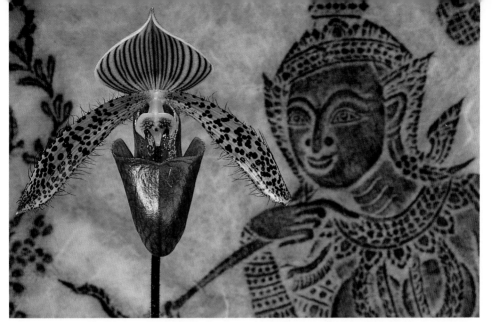

Backgrounds often complement and provide interest in photographs.
Here *Paphiopedilum* Oriental Spice is photographed
against a Thai temple rubbing.

Macro lenses offer quick focus adjustment from infinity down to 1/2 or
1:1 (actual film size). With a macro lens that offers 1:1 magnification a
flower two inches across would fill a 35mm slide or negative. Shown here
are three macro lenses focused on the orchid at the right. Far left is a
200mm lens, center 105mm and right 55mm lens.
All will photograph the *Phalenopsis* flower at the same size.

49

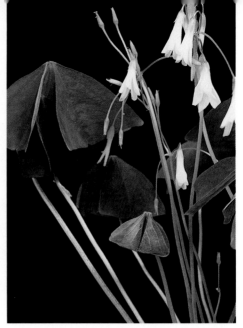

Oxalis regnellii thrives in a bright window or under fluorescent lights.

The same plant photographed at night shows the flowers closed.

Creating your own background allows you to control that element — used here, a plain white card so that the yellow lily 'Harlequin' would stand out.

For revealing close-up photographs fill the entire frame
with the subject matter. Here a spray of *Phalaenopsis* orchids includes
both front and profile views.

Here is a dramatic portrait of
Epithelantha micromeris created by
using careful lighting, including a
reflector below. The hand shows
relative size.

Add a ruler to scientific
photographs to show the precise
size of the subject.
Photographed here is
Anthurium scherzerianum.

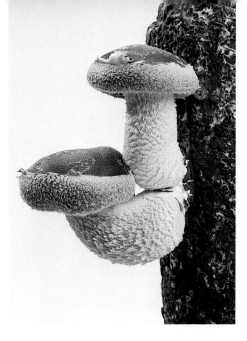

A sequence of photographs captures the dramatic development of *Lentinus edodes*, the shiitake mushroom, from budding spawn to mature crowns photographed with chopsticks.

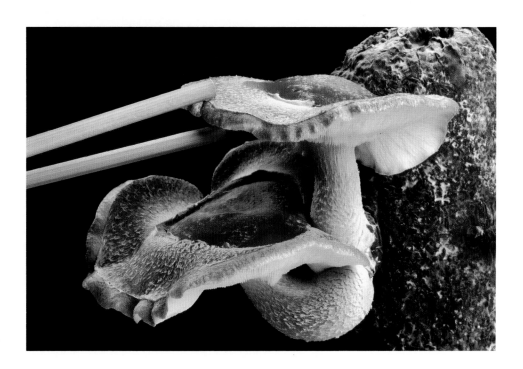

 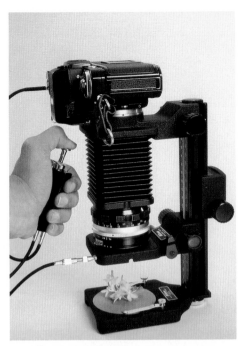

Well-designed tripods, such as this Bogen model, have sturdy controls to help with precise compositions.

For larger than life-size images on film use a bellows and lens reversed for maximum sharpness. Shown here is a double cable release used so that the lens iris can remain open for focusing but close quickly for the actual exposure.

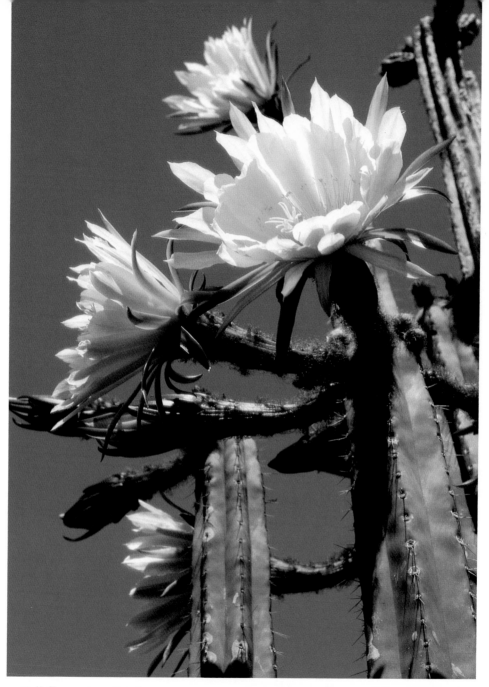

Tall flowering *Trichocereus* species growing outdoors at the Botanical Garden, University of California at Berkeley looks dramatic against a cloudless sky. The careful selection of angle includes stems, fruit and flowers of this cactus in various stages of development.

This sturdy but light weight tripod steadies a camera with 200mm telephoto lens in a Central American jungle setting. You will need a long lens to get frame-filling views of many plants in public gardens and natural habitats. Long lenses magnify camera shake so a tripod is useful.

Look for unusual combinations or placements of favorite plants, here native *Lilium auratum* and cultivated glad at a Tokyo subway stop.

PHOTOGRAPHING THE GRAND LANDSCAPE & CLASSICAL GARDEN

DEREK FELL

Several factors make the photographing of large gardens unusually difficult — the light can range from dark (as on a dismal, rainy day) to bright (as on cloudless, sunny days); the time of year can produce a lack of color (as in winter) or an abundance of color (usually in spring); also the plants can vary from disappointing one year (usually after a severe winter) to sensational another year (when nature has cooperated in providing all the right conditions). It is not easy to use artificial lighting in gardens and so we must rely almost entirely on natural light and the whims of Mother Nature, which is why garden photography is considered one of the most challenging forms of photography. I prefer to shoot large gardens on a slightly overcast day, rather than a sunny day — particularly a day with high cloud cover — since clouds diffuse the light, reduce harsh shadow contrasts and help sharpen colors. Some gardens even look good on a rainy day which tends to brighten up colors even more than the diffused light

DEREK FELL *is author of "How to Photograph Flowers, Plants & Landscapes" (HP Books). He is a frequent contributor to* **Architectural Digest, Connoisseur** *and* **The New York Times Magazine,** *specializing in photographing gardens worldwide, with an emphasis on garden design and portraying the romantic qualities of gardens.*

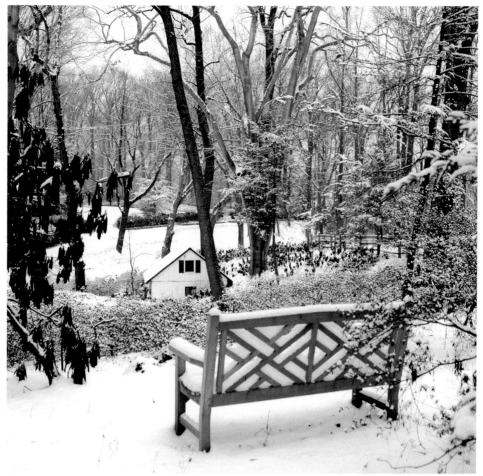

The secret of capturing good snow scenes is to photograph soon after the snow stops and before the sky clears. This timing takes advantage of the diffused light that a snow sky provides. The interestingly patterned bench is the focal point of this Deerfield Garden photograph.

PHOTOGRAPH BY DEREK FELL

alone. Oriental gardens, for example, with their emphasis on stone, evergreens and water can look fabulous in light rain, the droplets of rain shining up stone, producing ripples on water and enhancing the predominantly green landscape.

Though floral displays seem to last for weeks, it is amazing how a garden changes from minute to minute when the light and mood of the season become an important part of the composition. Wisps of mist and islands of light from a break in the clouds can be gone in a flash. Even a flowering cherry and an azalea seem to have a particular day when each is at its "peak of perfection". A day earlier or a day later can produce a totally different floral display. Good garden photographers learn to "read" a garden quickly, to anticipate those perfect

picture opportunities that are oftentimes so fleeting.

Morning light generally produces the best garden pictures. A bright, sunny day can yield disappointing results, offering little more than the opportunity to take what I call "cliche" pictures — the kind you see on a postcard rack. Morning light offers an opportunity to take "mood" pictures, such as a woodland pervaded with mist, or shadows streaked across an expanse of lawn. Late afternoon on can produce different effects from light. After about 3:30 p.m. in summer, for example, sunlight produces a lot of reddish tones, while a colorful sunset can offer the opportunity for some dramatic silhouettes. "Backlighting" can improve a so-so garden scene. Instead of always shooting with the sun behind you, try some scenes with the sun ahead, particularly through trees. This will give translucent objects, such as leaves and flower petals, a wonderful glow. However, you should use a lens hood to shade the lens from the sun or your exposures may show ugly streaks of extraneous light.

The best time of year to shoot a garden depends on the design and planting schemes of the garden, but a good photographer with an observant eye will never let the season hamper his ability to take good pictures. Even in winter when there may be little color, images that accentuate *textures* (such as bark and the patina of old stone) and *form* (such as the arching canes of bamboo silhouetted against a wintry sky and the sinuous branches of a contorted hazel) offer wonderful photo opportunities.

Obviously, a bulb garden will always yield its best color in spring, and a garden of annuals may reach its peak in midsummer. But good timing may depend on more than just choosing the obvious season. For example, a woodland garden can have a reputation as being sensational in spring, with freshly opened leaves forming a high overhead canopy and wildflowers carpeting the forest floor, but autumn may yield even more impressive compositions as the deciduous trees turn russet colors. And in winter, under a blanket of snow, the scene again changes — especially if a stream runs through to add valuable depth and contrast to the snowscape.

Great gardens rarely depend on one particular plant to make them look good, but certain plants do have the ability to create extremely colorful effects. Mass plantings of azaleas, dogwoods, daffodils, iris, daylilies and bluebonnets are examples of plants that can "paint" a grand landscape. Mass plantings like these tend to produce different effects in different years. Several years ago I wanted to visit Texas to photograph bluebonnet displays and found that a dry season had produced disappointing color, but the next year winter rains had been sufficient to create what was described as "the best bluebonnet displays in 20 years". That's when I headed for Texas!

When taking pictures in subdued light it is essential to use a tripod. Grand gardens generally have a lot of depth to them and it's important to get as much in focus as possible. This makes it essential to use high f/stops, such as f11 and f16 and even higher if your lens will allow. In poor light these high f/stops are possible only by keeping the camera absolutely steady by means of a sturdy tripod since you generally must use a slow shutter speed of one-quarter second or even one or two seconds in duration.

Another tip to help achieve sharp pictures is to avoid focusing on infinity, but to try to focus on something definite in the middle-ground or foreground, such as an interesting structure, a dominant tree or clump of conspicuous flowers.

Choice of film is another vital factor affecting the quality of your garden pictures. Avoid high-speed film, 25-, 50- and

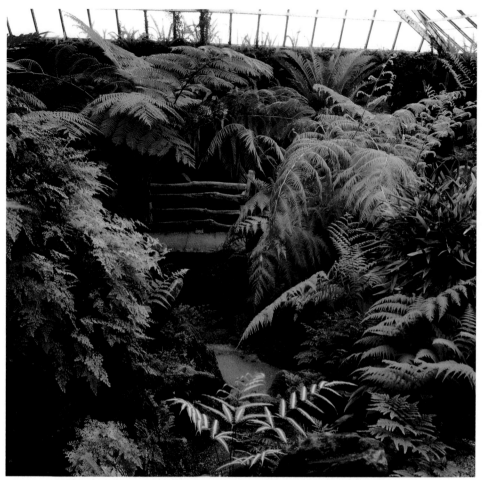

The bridge in the Fern Garden at the Morris Arboretum
provides an appealing design element especially in contrast to the
graceful, feathery fern fronds. The bridge is photographed off center to
show the small stream leading under the bridge.

PHOTOGRAPH BY DEREK FELL

64-speed films are the best to choose for good color saturation. My own preference is Ektachrome 64-speed "professional" film. I use slide film and if I want prints I can make inexpensive conversions from the best slides. If I want black and white prints I also make conversions from the slides. You can obtain "professional" film by special order through a camera dealer if he doesn't have any in stock. Ektachrome-64 film is extremely good at capturing blues and greens — very important colors in landscape and garden photography. However, its color stability can only be maintained by keeping the film cool and processing it soon after use. Kodachrome tends to produce better reds, but in my experience its greens are too "muddy" — particularly in shade and poor light situations.

Fujichrome 50 is my second choice after Ektachrome 64.

Never take your film to a one-hour photofinisher or similar mass-market film processor. I have found their photo finishing to be unacceptable, mostly because they often use inexperienced personnel and stale chemicals. Choose a good custom-processing house — or better still — use Kodak photo finishing. Kodak's standards of quality are the very highest.

Metering a garden for the correct exposure can be tricky, especially on sunny days when a wide variation of tones exist, from shaded to sunlit areas. Color film is not as versatile as the human eye in capturing detail in situations where there is high contrast. The best we can do is strike a happy medium or else decide what we want to have perfectly exposed — the shade or the sunlight. For example, if I am in a woodland with a tremendous contrast between the woodland floor and the overhead tree canopy, which may be brighly lit, I will decide what I want to show most — the woodland floor or the overhead tree canopy — and expose for one or the other with the aid of a "spot meter".

Spot meters are available as self-contained units, but in recent years some 35mm cameras — such as the Olympus system — have a spot-metering mode actually built into the viewfinder as one of the metering choices you can make. With this feature it's possible to take perfect pictures without bracketing, which is the practice of shooting one exposure at the camera's light reading, plus a stop above and a stop below as insurance. I find that with the Olympus system of built-in spot metering. I rarely have to bracket, except in situations where I deliberately want to underexpose or overexpose. If in doubt over a tricky lighting situation in a garden, I generally find it's better to err on the side of slight overexposure rather than underexpo-sure. This is particularly true in gardens with a lot of "greenery", since greens in a landscape usually can take a lot of overexposure before they look unacceptable.

When everything else is technically correct — lighting, focus, exposure, shutter speed — the final criterion for a sensational garden picture is *composition*. This you learn not only from practice but also from studying the work of other good photographers. For me a simple technique I call "framing" works wonders. Instead of taking a garden scene flooded with light as a flat panorama, consider adjusting your position so you have a clump of something out-of-focus in the foreground. It can be a spray of blossoms, some silhouetted leaves of a tree, lawn shadows across the ground — anything that helps fill in the edges like a picture frame.

When visiting gardens I always look for three types of composition — *overall views*, *specific views* and *close-ups*. The overall views help to establish a sense of place, give some idea of scope, capture a feeling of the environment. For example, if a garden is surrounded by mountains, try to include some of the peaks; if it is a seaside garden, include a portion of ocean, no matter how small the section of water might be. These overall views generally produce the most stimulating pictures. In order to include enough of the surroundings, a wide-angle lens (28mm) is sometimes needed, but a standard 50mm lens works well when using a 35mm camera system. Specific views usually concentrate on planting schemes and design concepts. They can show important features of a garden — a lake, a bridge, a flower garden or waterfall, for example. Close-ups mostly highlight details of individual plants or design details such as the carving on an urn or the expression on the face of a statue. With plant close-ups you can shoot a single flower, a cluster of berries, a group of

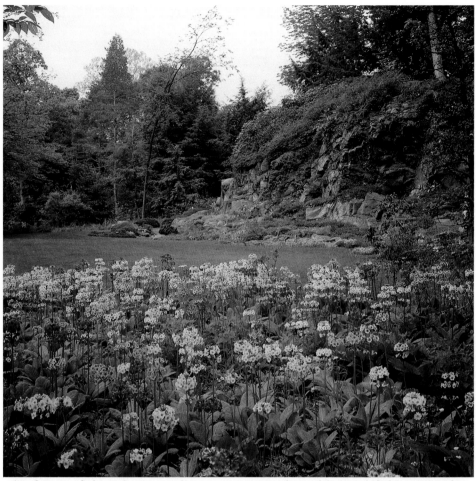

The focus of this photograph is concentrated on the candelabra primulas in the foreground. The overall view is of the rock garden at the Leonard Buck Garden in Far Hills, New Jersey.

PHOTOGRAPH BY DEREK FELL

leaves. You cannot create a good garden feature shooting only close-ups. They are mostly "fillers". It's the overall views — the vistas in particular — that make the best garden pictures.

For further study, I recommend a copy of "Deerfield — An American Garden Through Four Seasons" (Pidcock Press). A hardcover volume containing over 100 full-color photographs, it describes in words and pictures the mak-ing of a great American garden, showing scenes at every season of the year under every kind of lighting situation. Photographed over a period of three years, it won a Best Book award from the Garden Writers Association of America and contains a chapter explaining how the photographs were taken. Copies can be obtained from Pidcock Press, Box 1, Gardenville, PA. 18926 ($35.00 including shipping).

OPEN SHADOWS WRAP-AROUND LIGHT

CHARLES MARDEN FITCH

Strong back lighting provides good modeling for this frilly kale clump. A weak burst of flash from a hot shoe unit filled in the strong front shadows, to provide detail in the center leaves.

Two views showing effect of reflector: *Ascocenda* Surin 'Talisman Cove' photographed in full sun. When a silver reflector or white card is used to fill in harsh shadows the portrait shows more flower detail.

Portraits of flowers and plants often look best without harsh shadows. Dense shadows hide details of shape and color. But when light wraps around a subject, the shadows open and the eye, undistracted, is drawn to the plant. I especially like to apply lighting with open shadows to close-ups of complex flowers.

Light is a photographer's paint. I often spend five or ten minutes studying how to light a flower. By manipulating my lights and associated reflectors I can paint the subject with light in a revealing way.

To make light reach all visible parts of a complex flower, such as an orchid, I may reflect the main light into a photographic umbrella, then point the umbrella at my subject. With the umbrella off to one side the light quality is directional but soft and broad. To fill in the opposite side I use white or silver reflectors.

When a directional light isn't needed I put the umbrella right over or alongside the lens. This provides a flat, even light. With some subjects I may use a weaker direct light from behind left or behind right. This back light helps separate a subject from the background. It also makes hairs or ruffles in petals show up.

Another useful light control for diffuse broad lighting is called a light bank. Various brands use slightly different systems but the general design reflects a powerful electronic flash burst through one or two sheets of diffusion material. The light box or bank is often positioned above a subject. I like this sort of lighting for displays of vegetables, flowers in table settings, how-to-do displays involving

pots, plants and tools.

It is expensive to use this system since light bank diffusers require strong cool electronic flash but the quality of light delivered is useful for many horticultural subjects. Consider using light banks and powerful electronic flash if you are dedicated to horticultural studio photography. (For another approach to diffuse overhead lighting see *Photography Under Glass.*)

Reflective Surfaces

The umbrellas I use are white or silver. Silver provides more contrast and sparkle. White gives a flatter look. A similar difference occurs with different reflective surfaces inside a light bank. For very big subjects I might use a silver umbrella as the main light, then use a white umbrella on the darker side to fill in the shadows.

My reflectors are also matt white or silver. White reflectors are sections of stiff matt board or sections of foam core board, both available at art supply stores. Silver reflectors can be made from silver mylar adhesive paper, sold in hardware stores, or from aluminum foil on cardboard but for the most efficient effect I prefer silver reflectors made for photography.

My favorite reflectors are: Tota-Flectors made by Lowel Light Co. and a flexible, but tough foil called Rosco Featherflex made by Rosco Lab. These reflectors are sold by professional photography stores. Another useful reflector design involves reflective fabric on a twisting metal wire frame. The frame twists to fold into a circular size about one-third the open size, very convenient for location work.

Light Source

The light source you use to bounce into an umbrella and reflect into the shadows depends on your budget, artistic preference and working conditions. The least expensive light source is sunlight but it's not constant. Photoflood lamps are inex-

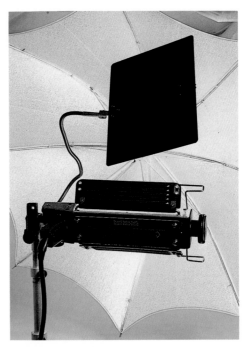

A tungsten halogen quartz lamp in a Tota Light fixture offers soft light when the beam is bounced into an umbrella. The black metal flag (top center) keeps light from hitting the lens and causing flare.

pensive but hot, and they change color temperature (get redder) as they age. Quartz-iodine lamps (halogen) are small, bright, and retain their designated color temperature with age. An example of fixtures that use quartz-shell halogen gas lamps are the Lowel lights.

All of the constant light sources (sun, photofloods and quartz lamps) let you see what the light is doing before you take the picture. With this advantage you can tailor the light to each subject, avoiding unwanted shadows and reflections. The main disadvantage of both quartz and photoflood lamps is heat, and a big demand on electricity.

For example, to get good depth of

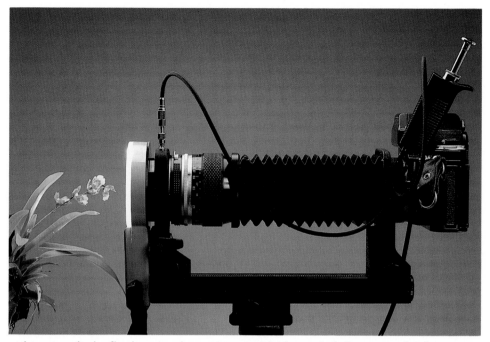

This ring-light flash provides very even light with fully open shadows. A bellows, reversed macro lens and ring light are useful for small subjects.

field (deep zone of sharp focus) one must use a small aperture (iris opening). To use a small aperture but still be able to use a shutter speed under one second, very bright lights are needed.

Using a high ISO film ("fast film") means you can use a small aperture at faster shutter speeds but a general rule about films is this: Film cost and grain effect rise with the ISO. Color quality and fine grain is best with low ISO films. For maximum quality slides use ISO 25 to 64 film. For best quality prints use ISO 25 to 100 negative color film.

Flash

My favorite light source for consistency is electronic flash. Flash is quick, bright, cool. A disadvantage of inexpensive portable flash units is that the final light can't be previewed. More costly studio flash units have built-in modeling or focus lamps which reveal what the final flash burst will look like.

A compromise to expensive studio electronic flash units with modeling lamps, is a low-wattage floodlight held in the same position as your small flash unit. With some practice you will be able to correlate what the tungsten lamp shows with what actually occurs when the flash goes off. With this system you are actually making your own modeling lamp.

Keep Tests

When you first experiment with any new lighting system keep notes and save all of your test exposures. Write down details for each frame. File the photos along with the associated notes. Use these test exposures to refresh your memory next time you use the same light arrangement. 📷

PHOTOGRAPHING PERENNIALS

MURIEL & ARTHUR N. ORANS

Perennials present an intriguing challenge to even the most experienced photographer. To capture them on slides or prints you must deal with the changing atmospheric conditions.

Take the time to familiarize yourself with your subject. If you garden, you have an image of what the plants look like. You've seen your subject under different lighting, and through the seasons. Take several pictures throughout the year to create a record.

Most anyone utilizing a modern auto-exposure camera can take correctly exposed pictures. Here are a few exposure and lighting considerations:

Exposure and Lighting Control

Take perennial pictures at any time of the year; in misty rain, fog, snow, blazing sunshine, early morning, at dusk or after

MURIEL AND ARTHUR ORANS, *award-winning horticultural photographers based in Oregon, have supplied photos to nursery, agricultural and media clients since 1956. Arthur passed away in April, 1989. Muriel continues the business.*

nightfall with artificial lighting. These atmospheric conditions provide challenges and opportunities for pleasant rewards.

We recommend the purchase of a Kodak gray card available at most camera shops. It provides the proper shade of gray needed by most built-in and hand-held light meters, to give the correct exposure. While professional photographers may intuitively know the correct exposure by the amount of sun or shade on their faces, remember that they have had years of experience. Use the meter reading indicated by the gray card. Test and record each exposure. These notes will help you recognize your own likes and dislikes in color saturation, reduction or extenuation of highlights, or contrasts. You will create your own aesthetically pleasing style.

Plants are the most difficult of all subjects to meter for the right exposure because of the limiting characteristics of the film. Fortunately color negative film for prints is quite forgiving as to exposure latitude.

Achillea in the background with a colorful annual border in the foreground.

PHOTOGRAPH COURTESY OF
HORTICULTURAL PHOTOGRAPHY, CORVALLIS OREGON

In contrast color slide films were not formulated to record the entire scale from black to white. They can reproduce a good part of it, but not all. For example, dark greens might as well be considered black. It is up to the photographer to decide which part of the gray scale should be emphasized. Home gardeners who want to understand the gray scale better, can purchase "The Exposure" by Ansel Adams.

Sunlight

❶ Time of day and latitude makes a big difference in the final color of the flower in the photograph — especially in the near whites!

a. Morning and evening sunlight has a very warming effect as the sun is near the horizon.

b. Outdoor film is color balanced for mid-day exposure.

❷ Your orientation to the sun makes a big difference in the final effect, which you can plan for by observing that:

a. Front lighting (coming from behind you) gives you the least amount of shadow and the greatest amount of color; however, the photograph has the least amount of apparent depth.

b. Back lighting (you are facing the sun) produces vibrant colors and dramatic pictures because of the deep shadows, but the film does not have the ability to produce information that your eye sees in the shadows; so you will get a lot less than what you see.

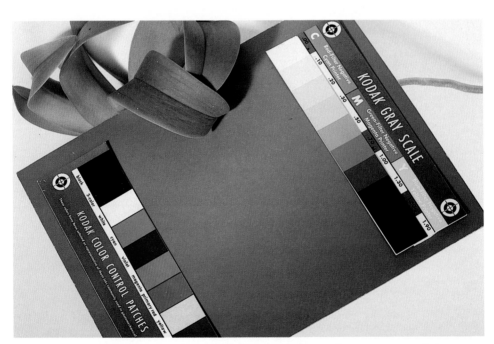

Color check cards and a photo gray scale shown here on a Kodak gray card are useful tools for testing film and equipment.

A Los Angeles perennial garden of roses and delphinium photographed against a green hedge for contrast.

c. Side lighting (more toward front lighting rather than back lighting) is ideal — especially when using a reflective white card to add light into the shadows.

Shady or Overcast Conditions

❶ These are the ideal conditions for photographing whites and pastels. Remember that in many petaled/double white flowers, i.e. clematis, shasta daisies, asters, the top petals will be the lightest colored — whitest, as each subsequent petal is inherently shadowed and will appear "grayer".

Filters

We consistently use a circular (versus linear) rotating polarizing filter to remove reflections. We use just a skylight filter when it is overcast or late in the evening. Reflections then are much less apparent.

Rotating polarizers allow photographers to get as much color saturation as they want by looking in the viewfinder and rotating the filter. A polarizer removes the hot spots, specular reflections that naturally disturb the photographer and view. Most 35-millimeter cameras with through-the-lens metering take into account the reduction in light caused by placing the polarizer in front of the lens. Green foliage can be rendered green, rather than white or washed out, if you use the polarizer.

Motion and Depth of Field Control

To achieve maximum depth of focus you must stop down the aperture and use a slow exposure. This creates motion prob-

71

lems with both the camera and the subject.

Solutions

To reduce camera motion, use a tripod in combination with any or all of the following: a) cable shutter release, b) locking up the camera mirror, c) utilizing the camera's self timer, d) increase shutter speed to the inverse of the focal length, i.e.: use 1/100 sec for a 100mm lens.

Subject motion occurs with the slightest puff of breeze, or in the constant winds that blow in some areas of the country. Plant structure and form come into play. Ways to control subject motion include creating wind blinds by using your body to shield plants, or constructing plywood barriers. Remember not to cast unwanted shadows on your subject. The use of plant stakes, c-clamps, pinch clamps and binder's twine painted dark green can be advantageous to perk-up shasta daisies, rudbeckia and other fragile plants. Insertion of floral wire through the back of the plant stems will also control motion.

Sacrificing depth of focus for motion control through increased shutter speed may be a necessity in areas where wind speeds exceed five to seven miles per hour.

Composition & Aesthetics

Beauty is in the eye of the beholder. And a decently composed illustration is what you want. Look at the photographs in garden books and mail-order nursery catalogs. Find what pleases you and go out with camera in hand and take pictures. You may want outside analysis of your photographs. Join a camera club in your area; members share their expertise.

A uniformly colored border of pink astilbes entices the eye to follow its curving seep.

PHOTOGRAPH COURTESY OF HORTICULTURAL PHOTOGRAPHY, CORVALLIS OREGON

Liatris, prominent in the foreground, and separated from a mixed border at the back accentuates the depth of the photograph.

PHOTOGRAPH COURTESY OF
HORTICULTURAL PHOTOGRAPHY, CORVALLIS OREGON

Here are three photographs taken under varying conditions with Kodachrome 64 and exposure taken from Kodak gray card.

Perennial border planted with Pacific hybrids.

❶ This was taken with a 35mm lens, with no filter, during a light rain. Meter reading 1/30th sec at F6.3. Rather flat lighting with depth created by color layering.

❷ Astilbe, taken with 50mm lens with UVA filter in open haze with a great deal of ground moisture. The tex-ture and color are paramount; expo-sure 1/30th sec at F11. Notice the ability to separate the subject from its background.

❸ *Liatris* taken in open sunlight again with 35mm lens with polarizer reducing reflection. Exposure at 1/100 sec at F11. Depth created by both camera angle and contrast of color up the hill.

To achieve a good technique, take notes. Write down your exposure time and aperture, time of day, atmospheric conditions, subject and comments. Review your pictures with your notes in hand. 📷

73

SPECIAL EFFECTS

CHARLES MARDEN FITCH

T he use of special photographic techniques can result in visual variations of a subject. Some of these techniques are almost routine, such as using a green filter in black and white photography so foliage appears a lighter shade of gray. Another effect, using a polarizing filter to get deep blue skies on color film, is a favorite with experienced landscape photographers.

This lily received two exposures on the same slide, one with flash (main exposure) and a second under exposure. Slight movement between the two exposures produces an outline.

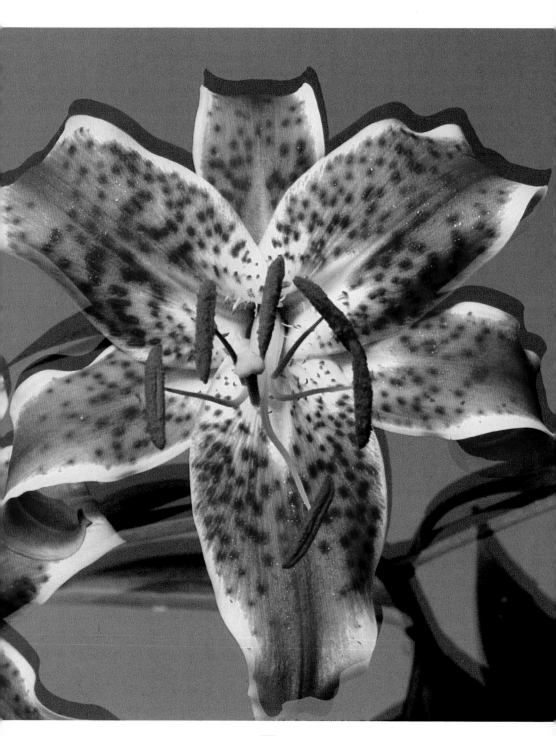

Filters are made of glass or plastic and fit in front of camera lenses. *Fog, soft, diffuser, mist* and similar descriptive names are devices used to render photographs less sharp. My favorite is called "Soft #1" by Nikon. It produces a gentle softening effect, mainly by making flare around reflections and lighter areas of the image.

The "Soft #1" filter creates the same sort of effect with any iris opening. Diffusers that have etched lines or sheets of mesh between glass differ in the effect they produce, according to the iris opening used.

The best way to learn about softening filters is to read the folders that accompany them, then take photographs at various iris openings.

Prisms held in front of the lens produce many different patterns. To avoid showing precise lines where prism facets

ABOVE:
The original color photograph used to make the black and white on the **FAR RIGHT.** This effect was produced by printing the original Kodachrome on black/white enlarging paper. The subjects: *Brassia caudata x B. gireoudiana.*

BELOW:
Color photographs can be used to decorate tee shirts. Here is a photograph of a *Phalaenopsis* orchid and as the photo appears used on a tee shirt.

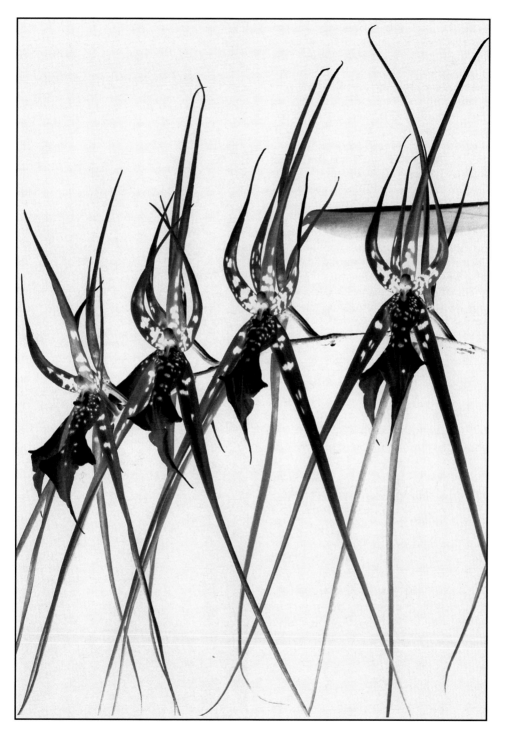

occur, use a wide to moderate iris opening. I like the prism that shows a clear image in the center, then repeats the subject as an overlapping image three or four times around the outside.

Some filters are made with two sections, one clear and the other tinted. A blue tint can be rotated so a dull sky takes on more color. Several filter firms offer booklets that illustrate the effects possible with various colors.

Aside from using filters to get special color effects you can experiment with mismatches of film to light source. If you want to create a moody blue in a misty spring landscape use tungsten balance film, such as Ektachrome-160, in daylight. The resulting slides will all be blue-tinted. The reverse occurs if you use daylight balanced color film under tungsten lamps. For example, a red rose photographed on Kodachrome-25 by the

ABOVE:
A red and yellow miniature rose covered with dewdrops was photographed on Kodachrome film.

FAR RIGHT:
This slide was then printed on standard black/white enlarging paper.

BELOW:
This close view of a split *Capsicum* fruit was created by sandwiching two slides together.

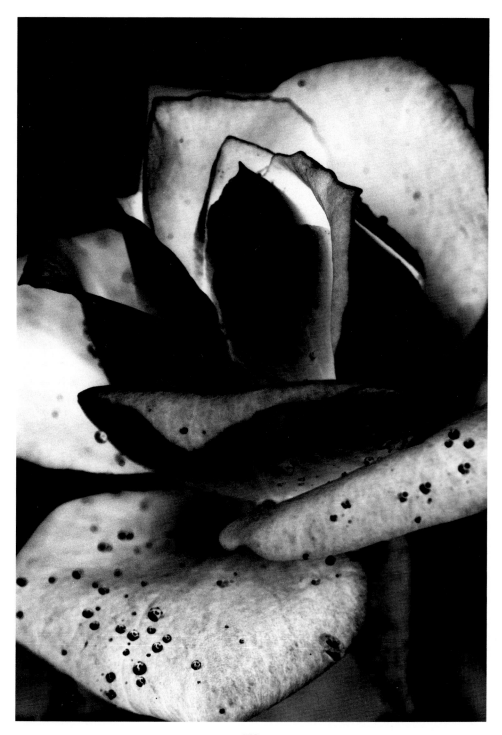

light of a tungsten lamp will be an abnormally rich red.

Versatile cameras often permit a precise double exposure. A good use of the double exposure effect would be to show a profile and a front view of a single flower on one frame of film. For effective double exposures use a black back-

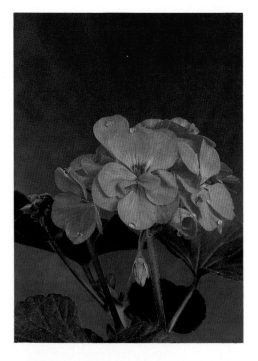

ABOVE:
Pelargonium 'Jazz' photographed with 105 macro lens on hand painted oil background.
SECOND VIEW BELOW:
A soft filter was added.

OPPOSITE PAGE ABOVE LEFT:
Using a macro lens and a 35mm Nikon camera and shooting at a low angle, allows the photographer to capture snowdrops, *Galanthus elwesii.*

OPPOSITE PAGE ABOVE RIGHT
A perspective control lens, here on a 35mm SLR, permits photographing tall trees and building landscape combinations without tilting effects. When a camera is tilted to capture a tall subject, the object appears distorted. The perspective control lens shifts so tall subjects can be shown while the camera remains parallel to the subject thus avoiding converging vertical lines.

OPPOSITE PAGE BELOW:
Filters help balance light sources and render subjects the way a photographer prefers. Filters come with precise instruction sheets. Some film instructions mention specific filters for various applications.

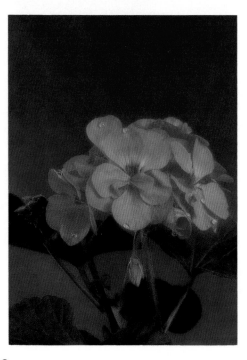

ground. Place the subject in a different part of the frame for each exposure, unless you want an overlap.

Some special effects are best done in a photographic darkroom because they require printing and developing with light-sensitive papers. Photograms show interesting plant parts in a reverse image. Since photograms are made by placing flowers, leaves or seeds in direct contact with photographic printing paper they show the plant parts in actual size.

A variation in photograms involves printing a standard negative on to photographic paper in combination with actual objects on the paper during exposure. For example, a view of a fern clump in the garden might be printed in the center while actual fronds surround the central image.

A zoom lens can help create some special effects. Put the camera on a tripod,

RIGHT:
Blc. Chindavanig photographed without and with a prism.

OPPOSITE PAGE ABOVE:
Paphiopedilum Niobe photographed against silver mylar produces a reflection and an unusual effect.

OPPOSITE PAGE BELOW:
Clear glass prism multiplies yellow tulips.

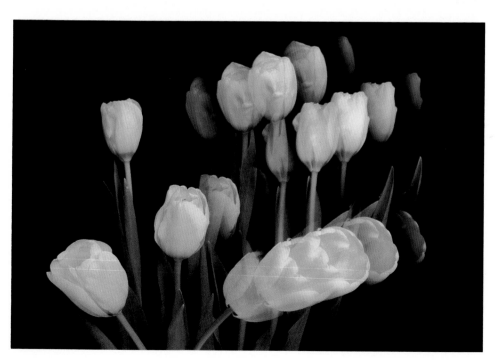

83

use a slow exposure of one or two seconds during which you zoom in or out. Interesting blurs result around the subject. This effect looks best in color. Combine the zoom effect with flash to get even greater variations or use multiple exposures on the same frame of film with a zoom move between each.

When the original color slide is projected by an enlarger on to black and white printing paper a dramatic reverse image is produced that looks like a new black orchid! Many of these special effects are appropriate to illustrate creative writing or as fantasy prints for display.

RIGHT:
Two landscape views
of sunrise on Ashley River,
South Carolina,
one with a prism
to create
rainbow flares.

OPPOSITE PAGE:
Above, a view before zoom.
Below, the effect of zoom lens
being zoomed during a long
exposure of the same view above.

SOURCES OF EQUIPMENT & INFORMATION

B & H PHOTO
119 West 17th St.
NY, NY 10011
General discount photo store with full line of cameras, lenses, cases, tripods, films, professional supplies. Free price list.

BOGEN PHOTO CORP.
17-20 Willow St., P.O. Box 712
Fair Lawn, NJ 07410-01712
Tripods and background supports. Free folders.

CALUMET PHOTOGRAPHIC
890 Supreme Drive
Bensenville, IL 60106
Full catalog of cameras, lenses, flash units, cases, darkroom supplies and film.

CANON U.S.A.
One Canon Plaza
Lake Success, NY 11042
Canon cameras and lenses. Free folders.

Pear *Pyrus calleryana*
in spring bloom.

Pear *Pyrus calleryana*
in summer.

CHIMERA PHOTO LIGHTING
1812 Valtec Lane
Boulder, CO 80301
Diffusion light banks. Free catalog.

FUJI PHOTO FILM U.S.A.
555 Taxter Rd. • Elmsford, NY 10523
Film and cameras. Free folders.

GMI PHOTOGRAPHIC INC.
1776 New Highway
Farmingdale, NY 11735
Importer for Cullmann tripods, various cases, and Bronica medium-format cameras. Free folders.

KEN HANSEN
920 Broadway • NY, NY 10010
Cameras, lenses, lighting equipment. Professional lighting division.

VICTOR HASSELBLAD
10 Madison Rd. • Fairfield, NJ 07006
Hasselblad medium-format cameras and lenses. Free folders.

EASTMAN KODAK CO.
343 State St. • Rochester, NY 14650
Film, cameras, darkroom supplies, books. Free folders and advice.

LEPP & ASSOCIATES
P.O. Box 6240 • Los Osos, CA 93412
Macro photography accessories and other equipment designed for nature photographers. Free catalog.

LIGHT IMPRESSIONS
439 Monroe Ave.
Rochester, NY 14607
Books, print and slide storage supplies. Free catalog.

LIGHTWARE, INC.
1541 Platte St.
Denver, CO 80202
Padded professional cases for cameras and lighting equipment.

LOWEL-LIGHT MFG., INC.
140 58th St. • Brooklyn, NY 11220
Reflectors, lights, stands, related equipment.

Pear *Pyrus calleryana*
in fall.

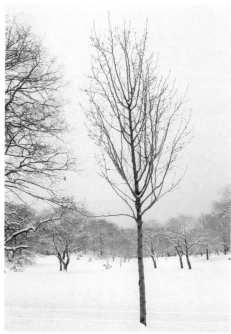

Pear *Pyrus calleryana*
in winter snow.

MAMIYA AMERICA CORP.
8 Westchester Plaza
Elmsford, NY 10523
Medium-format Mamiya cameras and lenses. Free folders.

MINOLTA CORP.
101 Williams Drive • Ramsey, NJ 07446
Minolta cameras and lenses. Free folders.

NIKON INC.
19601 Hamilton Ave.
Torrance, CA 90502-1309
Nikon cameras, lenses, flash units, filters, and related accessories. Free folders describe products.

OLYMPUS CAMERA CO.
Woodbury, NY 11797
Olympus cameras, lenses, system accessories. Free folders.

PHOTEK
909 Bridgeport Ave. • Shelton, CT 06484
Background materials and photo umbrellas.

POLAROID CORP.
575 Technology Sq.
Cambridge MA 02139
Instant films, cameras. Free folders.

PORTER'S CAMERA STORE
Box 628 • Cedar Falls, IA 50613
General mail-order catalog of photo equipment, film and darkroom supplies, many accessories. Free catalog.

QUANTUM INSTRUMENTS, INC.
1075 Stewart Ave.
Garden City, NY 11530
Flash battery packs, wireless slaves.

SAVAGE UNIVERSAL CORP.
850 Third Ave. • NY, NY 10017
Savage seamless background paper. Free color chart.

SEKONIC R.T.S.
40-11 Burt Drive • Deer Park, NY 11729
Sekonic meters to measure flash and ambient light. Free folders.

THE SETSHOP
3 West 20th St.
NY, NY 10011
Supplies for studio photography. Backgrounds, supports, gels and diffusion materials.

TAMRAC, INC.
6709 Independence Ave.
Canoga Park, CA 91303
More than 40 different camera bags. Free catalog.

TEKNO-BALCAR
38 Greene St. • . • NY, NY 10013
Balcar professional studio flash systems and portable flash, stands, reflectors. Branch offices in Chicago, Los Angeles and Ontario.

VIVITAR CORP.
9350 DeSoto Ave.
Chatsworth, CA 91313
Lenses, flash units, cameras. Free folders.

WEIN PRODUCTS, INC.
115 West 25th St.
Los Angeles, CA 90007
Infrared flash triggers, slave units, cords.

READING LIST

For more information about photographing gardens and plants consult these publications:

ORCHID PHOTOGRAPHY (American Orchid Society handbook)

THE RODALE BOOK OF GARDEN PHOTOGRAPHY by Charles Marden Fitch (Amphoto/Watson-Guptill, NY)

PRO TECHNIQUES OF LANDSCAPE PHOTOGRAPHY by Josef Muench (HP Books, Tucson AZ)

CLOSE-UP PHOTOGRAPHY (Eastman Kodak Pub. K-22)

LANDSCAPE PHOTOGRAPHY (Eastman Kodak Pub. AC-97)